Remembering
Chattanooga

William F. Hull

TURNER
PUBLISHING COMPANY

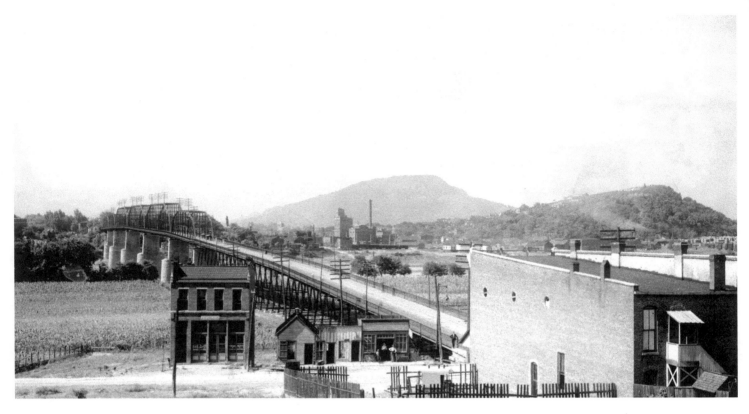

View of downtown Chattanooga from the north side of the Tennessee River, known as Hill City. The two-story building to the right is the Hill City Post Office on Frazier Avenue. Directly behind it stands the Walnut Street Bridge. In the center background the large building with the smokestack is the Chattanooga Brewery; to its left stands the distinctive tower of St. Paul's Episcopal Church. Photograph by W. H. Stokes (ca. 1896)

Remembering
Remembering
Chattanooga

Turner Publishing Company
www.turnerpublishing.com

Remembering Chattanooga

Library of Congress Control Number: 2010902277

ISBN: 978-1-59652-603-7

Printed in the United States of America

ISBN 978-1-68336-814-4 (pbk.)

CONTENTS

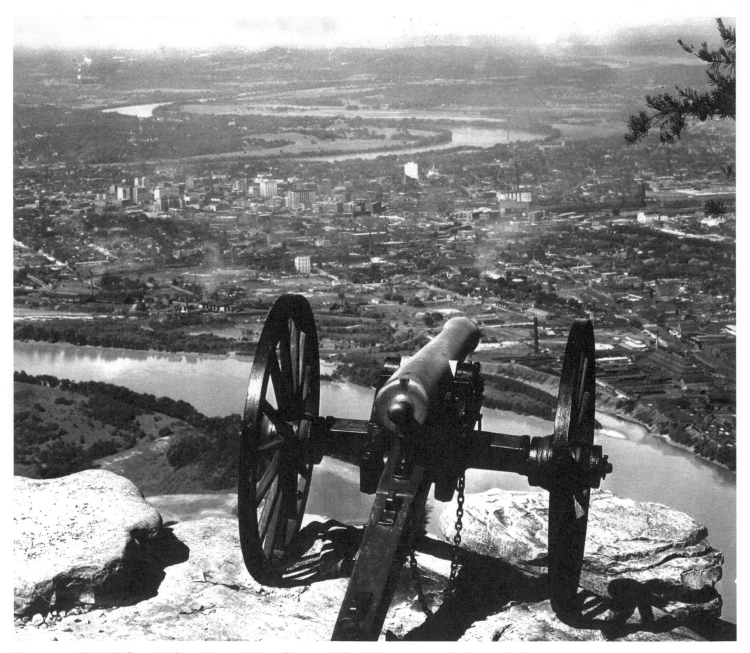

A cannon at Point Park on Lookout Mountain is a silent reminder of the great struggle that took place in Chattanooga during the American Civil War.

Acknowledgments

This volume, *Remembering Chattanooga,* is the result of the cooperation and efforts of many individuals and organizations. It is with great thanks that we acknowledge the valuable contribution of the following for their generous support.

Chambliss, Bahner & Stophel, P.C.
Erlanger Medical Center
Miller & Martin, PLLC

Chattanooga Fire Department
Chattanooga–Hamilton County Bicentennial Library—Local History and Genealogy Department
Chattanooga Regional History Museum
Tennessee American Water
Tennessee State Library and Archives

We would also like to express our gratitude to Karen Myrick for providing research, assisting the author, and contributing in all ways possible.

And finally, we would like to thank the following individuals for their valuable contribution and assistance in making this work possible:

Bruce Garner, Chattanooga Fire Department
Randall Herron, Chattanooga Fire Department
Karina McDaniel, Tennessee State Library and Archives
Mrs. Earl E. Millwood, daughter of the late Paul Heiner
Jim Reece, Chattanooga–Hamilton County Bicentennial Library

PREFACE

Chattanooga has thousands of historic photographs that reside in archives, both locally and nationally. This book began with the observation that, while those photographs are of great interest to many, they are not easily accessible. During a time when Chattanooga is looking ahead and evaluating its future course, many people are asking, How do we treat the past? These decisions affect every aspect of the city—architecture, public spaces, commerce, tourism, recreation, and infrastructure—and these, in turn, affect the way that people live their lives. This book seeks to provide easy access to a valuable, objective look into Chattanooga's history.

The power of photographs is that they are less subjective than words in their treatment of history. Although the photographer can make subjective decisions regarding subject matter and how to capture and present it, photographs seldom interpret the past to the extent textual histories can. For this reason, photography is uniquely positioned to offer an original, untainted look at the past, allowing the viewer to learn for himself what the world was like a century or more ago.

This project represents countless hours of research and review. The researchers and author have reviewed thousands of photographs in numerous archives. We greatly appreciate the generous assistance of the archivists listed in the acknowledgments of this work, without whom this project could not have been completed.

The goal in publishing this work is to provide broader access to a set of extraordinary photographs that seek to inspire, provide perspective, and evoke insight that might assist people who are responsible for determining Chattanooga's future. In addition, the book seeks to preserve the past with adequate respect and reverence.

The photographs selected have been reproduced in vivid black-and-white to provide depth to the images.

With the exception of touching up imperfections that have accrued with the passage of time and cropping where necessary, no changes have been made. The focus and clarity of many images are limited to the technology and the ability of the photographer at the time they were recorded.

The work is divided into eras. Beginning with some of the earliest known photographs of Chattanooga, the first section records photographs from the Civil War through the end of the nineteenth century. The second section spans the beginning of the twentieth century to World War I. Section Three moves from World War I to World War II. Finally, Section Four covers World War II to the 1960s.

In each of these sections we have made an effort to capture various aspects of life through our selection of photographs. People, commerce, transportation, infrastructure, religious institutions, educational institutions, and scenes of natural beauty have been included to provide a broad perspective.

We encourage readers to reflect as they walk through the streets of downtown, along the riverfront, or atop Lookout Mountain. Cannons were once positioned around the city, riverboats once pulled up along the banks of the Tennessee, and many buildings, long since demolished, stood where newer buildings of the late twentieth century stand today. It is the publisher's hope that in utilizing this work, longtime residents will learn something new and that new residents will gain a perspective on where Chattanooga has been, so that each can contribute to its future.

—*Todd Bottorff, Publisher*

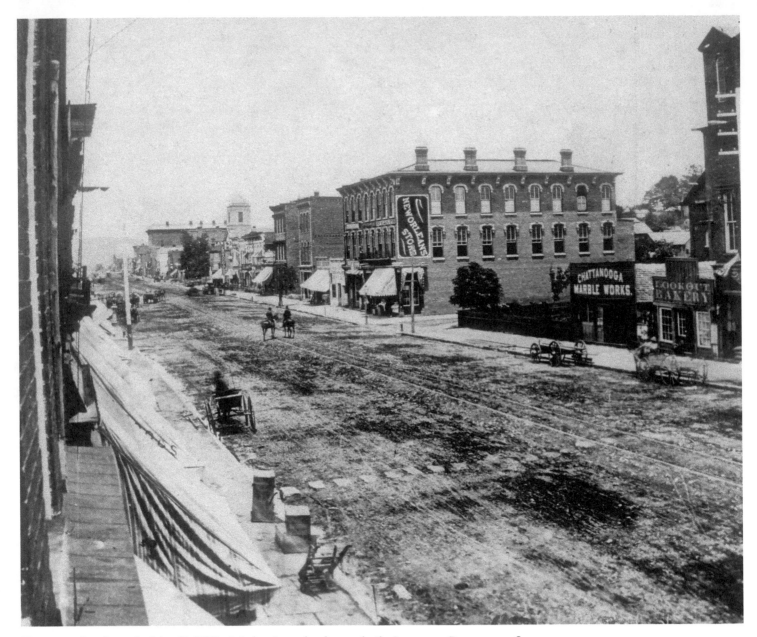

Ten years after the end of the Civil War, Market Street has been rebuilt. Lovemans Department Store will be built at the corner of Market and 8th streets where the marble yard stands. The steeple in the distance on the right side of the street belongs to the First Presbyterian Church. (1875)

Eve of the Civil War to the Centennial

(1850s–1899)

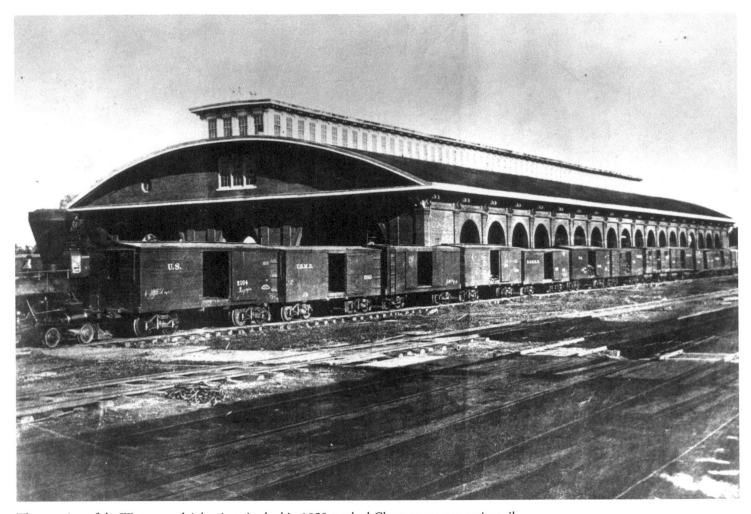

The opening of the Western and Atlantic train shed in 1858 marked Chattanooga as a major rail center. The shed, which faced the Crutchfield House, was three hundred feet long, one hundred feet wide, and served three railroads at that time. Following the fighting at Stones River and Chickamauga during the Civil War, it was filled with the wounded and the dying for days.

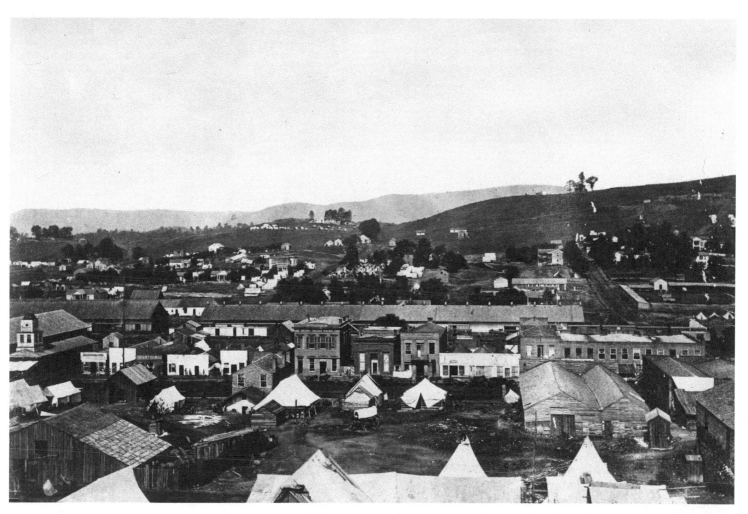

Wartime view of Chattanooga looking west toward Cameron Hill. Building at far-left with the bell tower is City Hall, located on Market Street. Flag draped on Kennedy-Nottingham house in far background indicates that the body of General McPherson, killed in the Battle of Atlanta, lies in state there. (July 1864)

View of Chattanooga under Union occupation looking southwest with Lookout Mountain in the background. Church at left-center is First Presbyterian, which was shelled by Union artillery during a special service. Behind the church sits the long Western and Atlantic train shed. The locomotive station was situated across from the Crutchfield House on what was formerly Ninth Street. (1864)

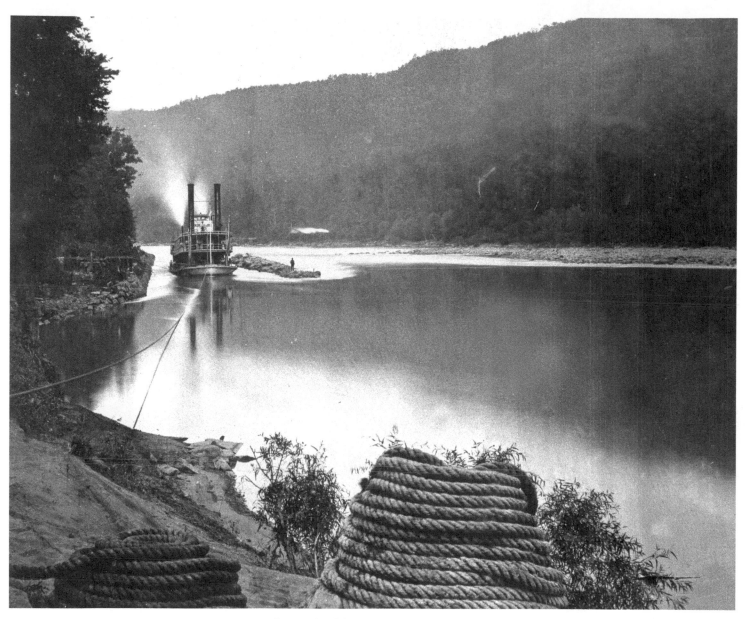

Navigating the rapids of the Tennessee River could be treacherous. Here huge ropes "warp" or draw a vessel safely through "the Suck." (ca. 1863)

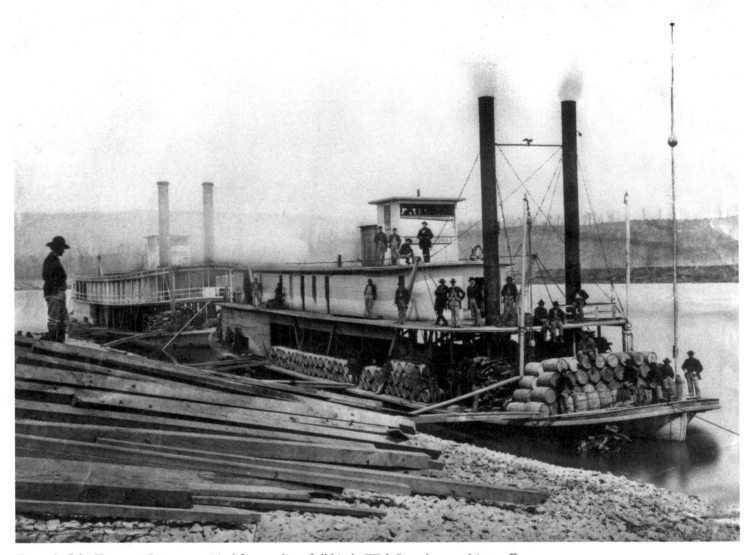

Control of the Tennessee River was critical for supplies of all kinds. With Bragg's army driven off Lookout Mountain, the waterway was clear for steamers like the *Chattanooga* and *Missionary* to bring food and materials to the Union army. By 1864, as goods came into the city, Chattanooga became a giant supply depot for Sherman's march into Georgia. (1864)

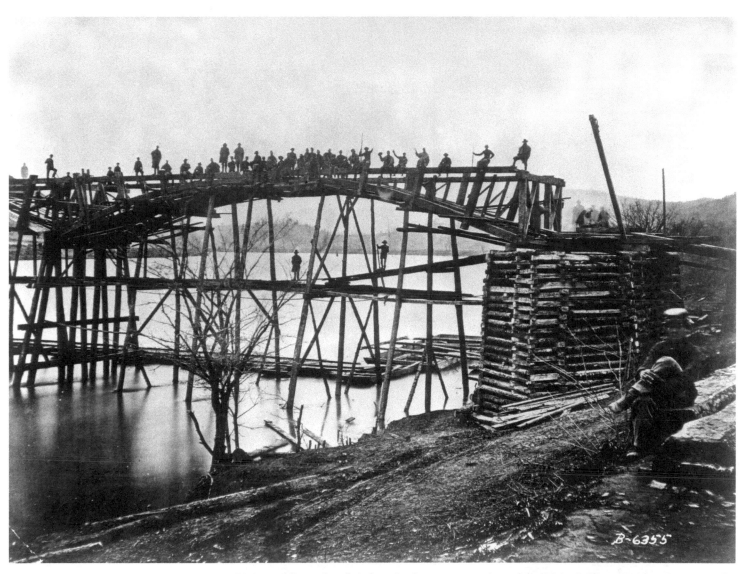

Union soldiers take a brief respite from construction of the Meigs Military Bridge. Spanning the Tennessee River near the present-day Market Street Bridge, the wooden bridge was torn from its moorings in the flood of 1867. The use of lumber for building projects by the United States Army Engineers left Chattanooga treeless and barren-looking.

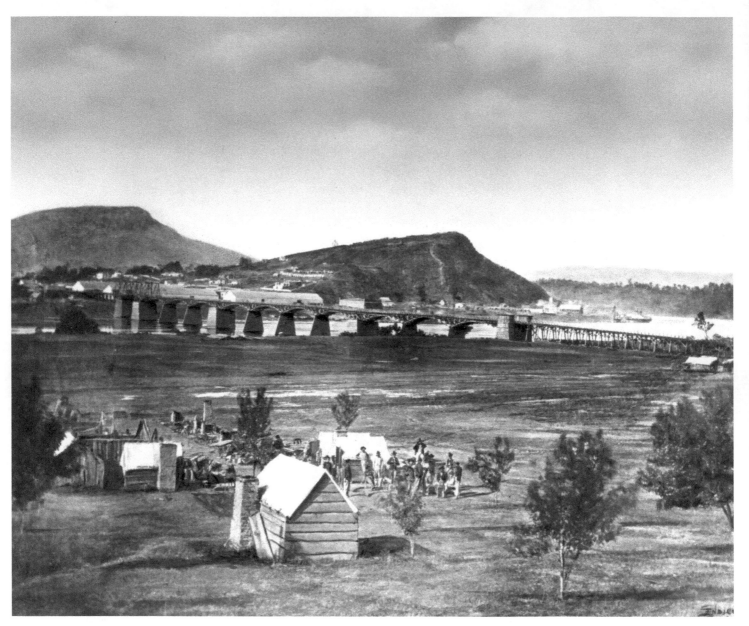

View of Chattanooga looking south across the Tennessee River from North Chattanooga. Spanning the river is the Meigs Military Bridge, which would remain until a raging flood in 1867 swept it away. Troop encampments are visible in the foreground of the photograph; Cameron Hill stands in the center; Lookout Mountain is in the background to the left.

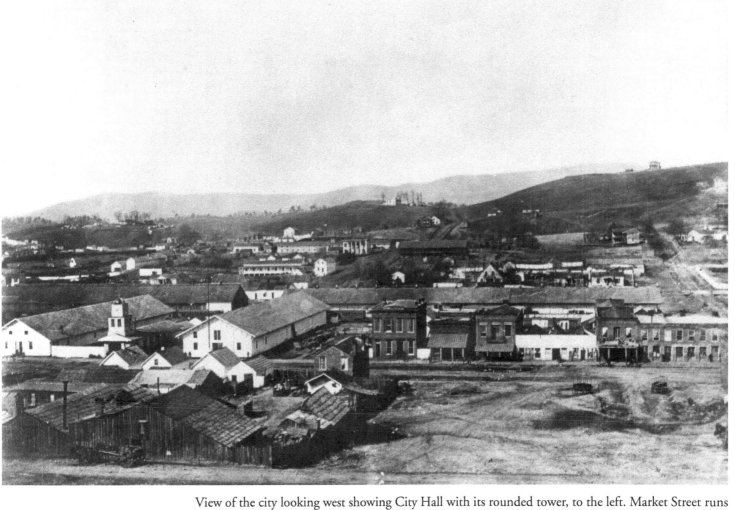

View of the city looking west showing City Hall with its rounded tower, to the left. Market Street runs in front of City Hall; behind it in the distance stands the columned Kennedy-Nottingham House. (1864)

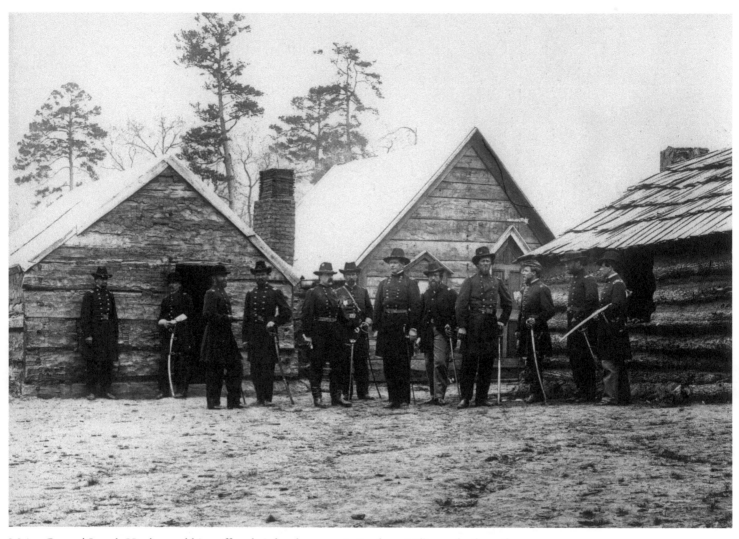

Major General Joseph Hooker and his staff at their headquarters in Lookout Valley at the foot of Lookout Mountain. This scene from the winter of 1863 to 1864 shows them in camp after his troops had stormed the mountain in the famous "Battle Above the Clouds" and driven the Confederate forces back toward Georgia. (1864)

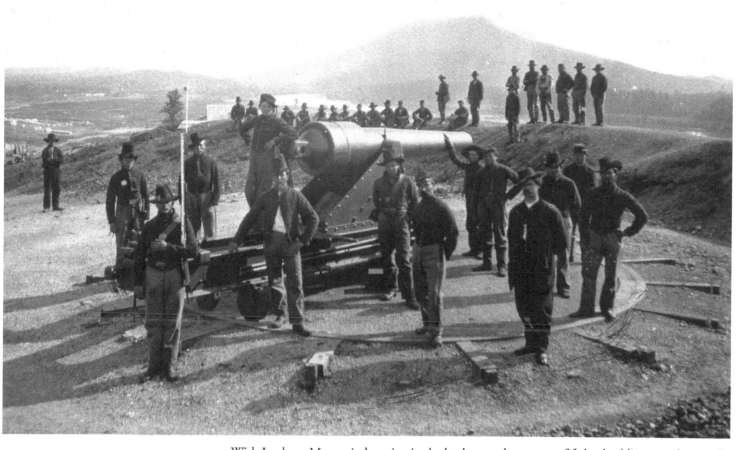

With Lookout Mountain looming in the background, a group of federal soldiers stands proudly with a two-hundred-pound cannon at Battery Coolidge on Cameron Hill. The circular track assembly at this bend in the river made this an effective weapon of war. The soldier second to right lived to be 109 years old, passing away in 1956. (ca. 1864)

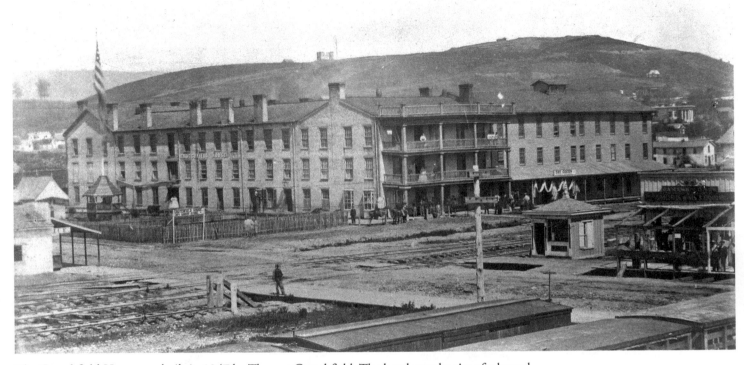

The Crutchfield House was built in 1847 by Thomas Crutchfield. The hotel was the site of a heated scene in 1861 when a secessionist speech by Jefferson Davis touched off political passions. The hotel burned in 1867 and was replaced by the Read House. (ca. 1865)

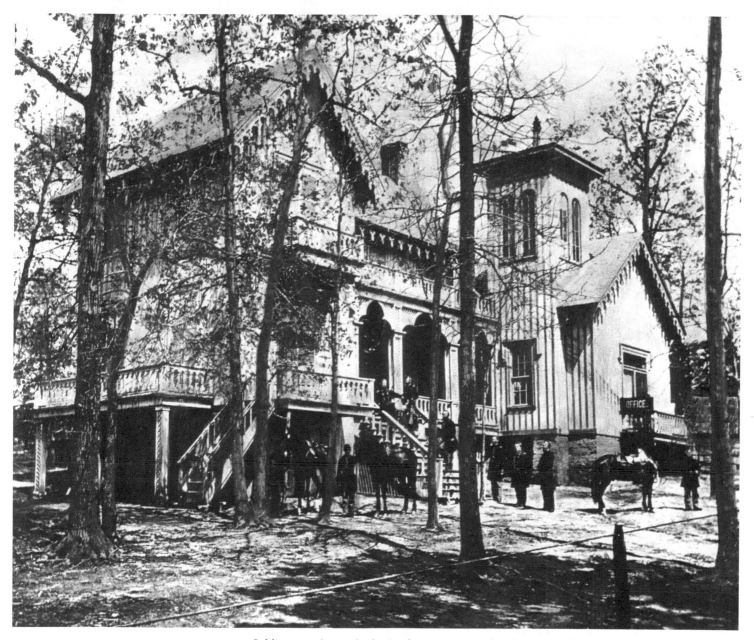

Soldiers stand outside the Lookout Mountain headquarters of General Joe Hooker during the Civil War. Located near the present-day intersection of Scenic Highway and Hermitage Road, the establishment was known as the Cottage Home Hotel. (1864)

One of the first banks to open in Chattanooga after the Civil War was the First National Bank, which began operation on October 25, 1865. Its founders were William P. Rathburn and Theodore G. Montague. The business merged with the Chattanooga Savings Bank and Trust Company in 1929 on the eve of the Great Depression. (ca. 1869)

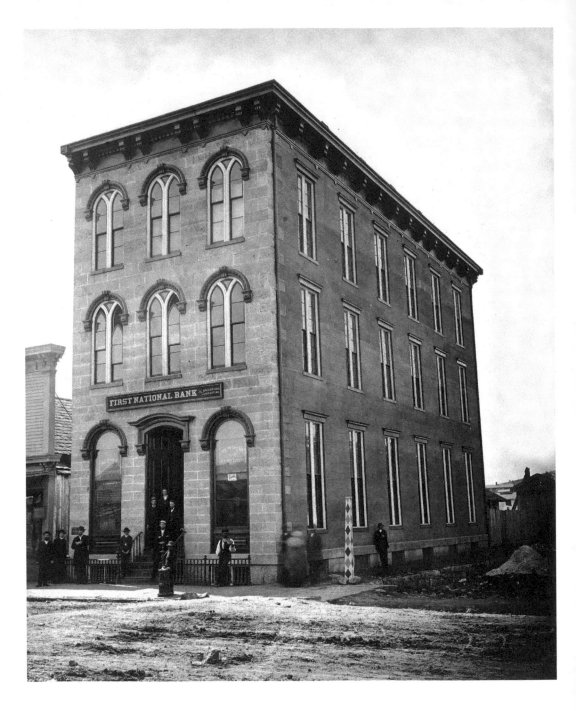

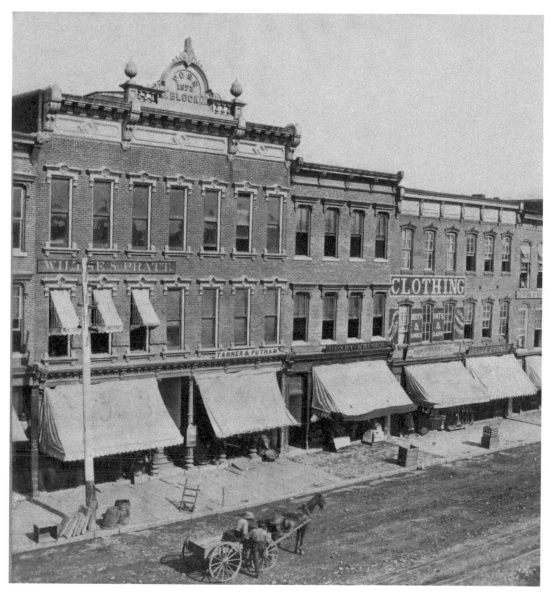

Two men in a wagon on Market Street pause before merchant stores on the Poss Block. Tracks are visible to the lower right. Chattanooga had established a horse-drawn trolley line in 1875. (ca. 1880)

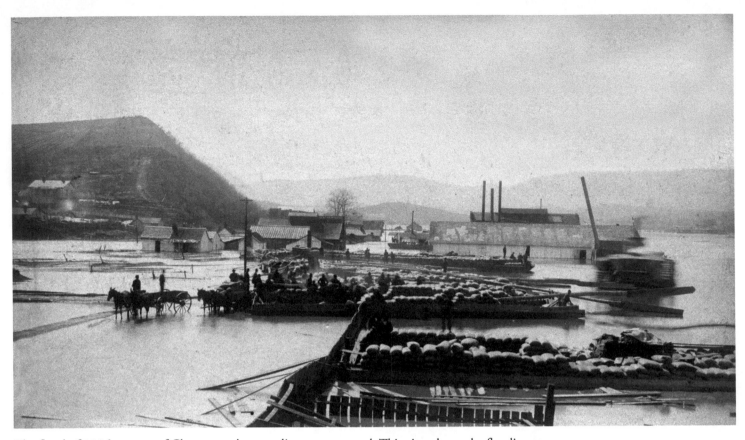

The flood of 1886 was one of Chattanooga's worst disasters on record. This view shows the flooding at Ross's Landing with Cameron Hill in the background. Floods were a constant problem, especially for downtown Chattanooga. (1886)

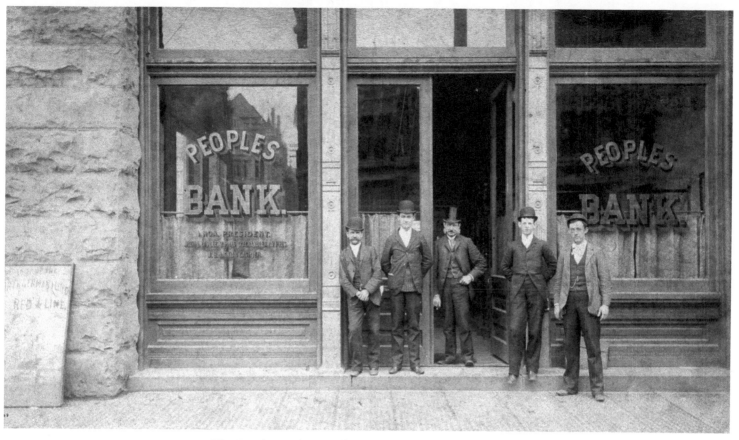

The Peoples Bank opened in 1887 amid an economic boom in Chattanooga. Bank president, Ismar Noa, is easily identifiable in the center with his mutton chops and top hat. (1890)

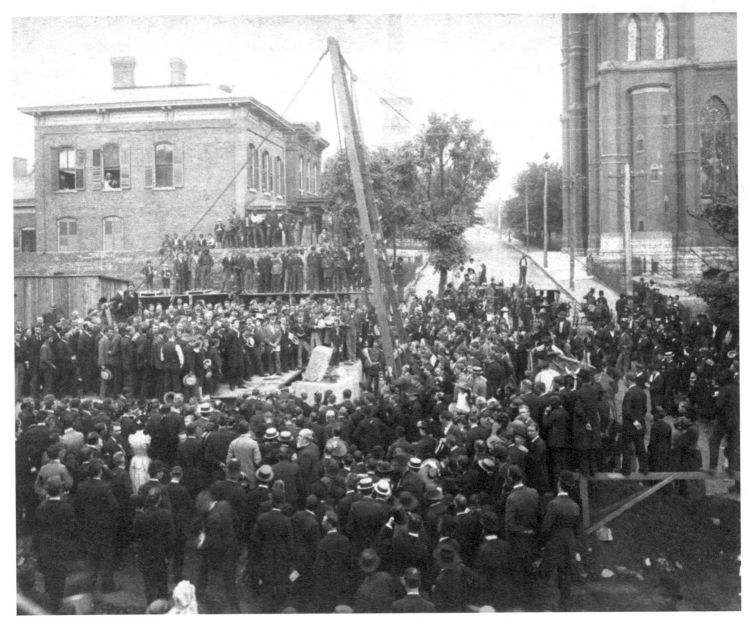

When Adolph Ochs purchased the *Chattanooga Times* in 1878, it was a struggling newspaper. By 1891 he was successful enough to finance his own building to publish the paper. Here a crowd gathers at Georgia and 8th streets to witness the laying of the cornerstone of the Dome building. (1891)

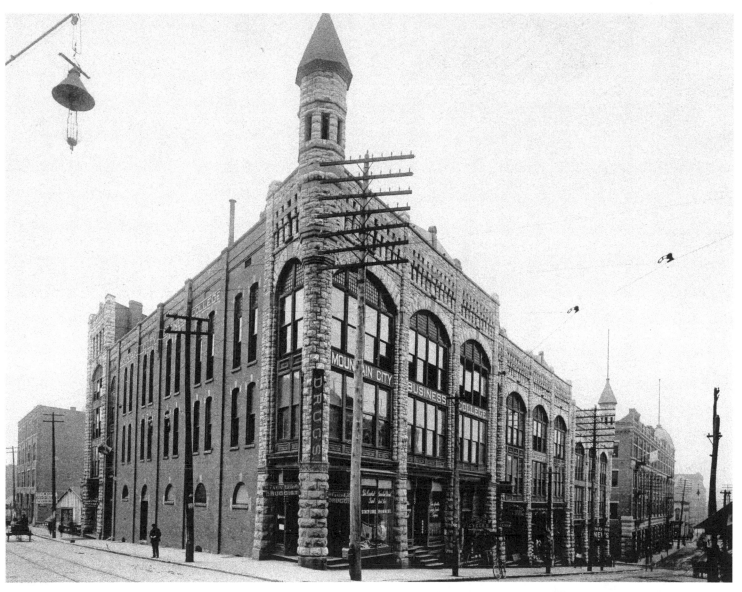

View of the Adams Block, built by John Wesley Adams in 1881, at the corner of Georgia Avenue and 8th streets. The striking tower and elaborate stonework stood for one hundred years, before it was demolished in 1980.

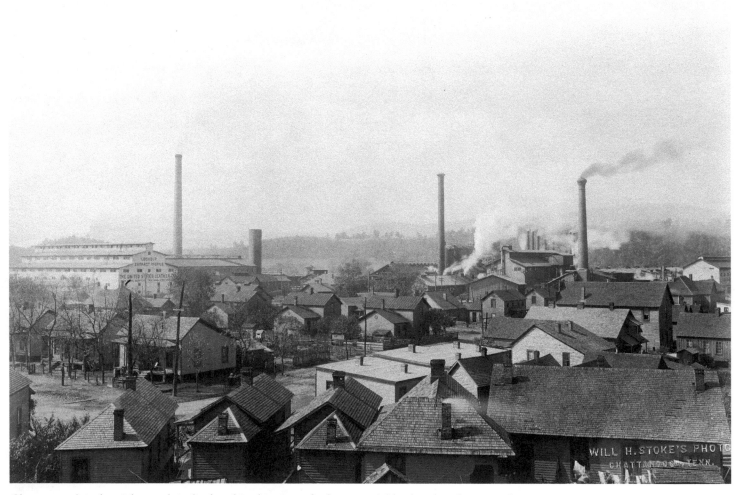

Chattanooga's industrial growth is displayed in this view of a factory neighborhood to the west of Cameron Hill near the Tennessee River. Workers commonly lived close to the worksite, such as the Lookout Factory Works on the far left or the Chattanooga Iron Furnace Company in the center background. Photograph by William Stokes (ca. 1890)

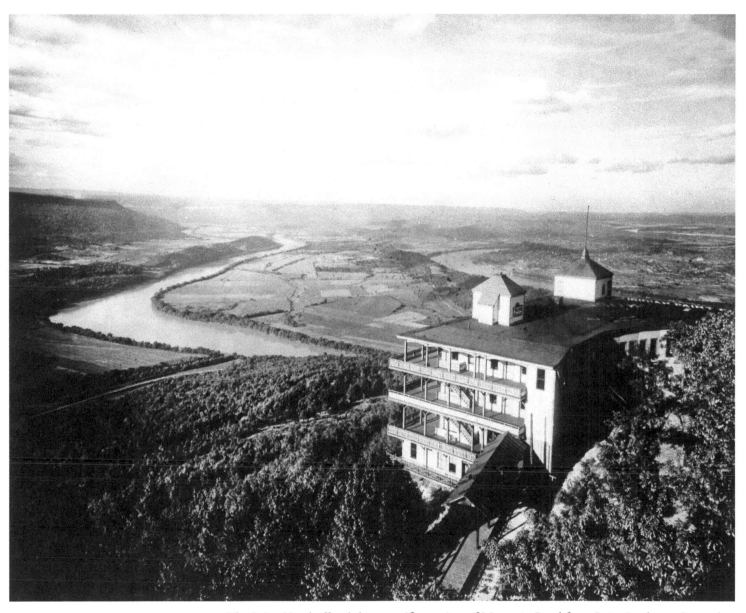

The Point Hotel offered this magnificent view of Moccasin Bend from Point Lookout. Opened in 1887, it was served by a narrow gauge railway. Visible on the roof of the hotel are the words "Iridian Paint Co." Photograph by W. H. Stokes (ca. 1895)

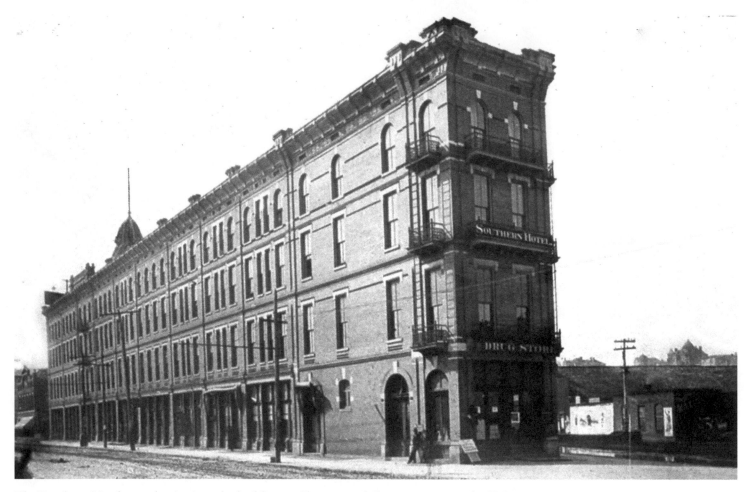

The Southern Hotel was a long, triangular building at Chestnut and Carter streets near the Union Depot. Constructed as the Palace Hotel in 1887, it was taken down in 1972 along with the rail depot. (1895)

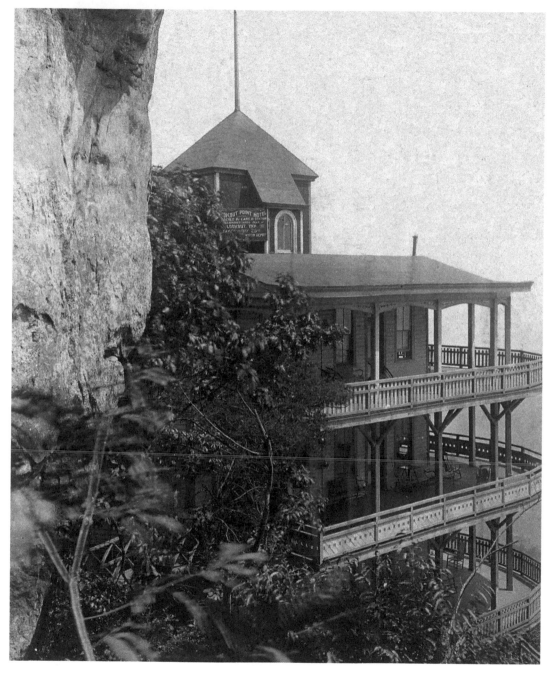

The Point Hotel was a remarkable edifice with a spectacular panorama across the horizon above Moccasin Bend. The hotel featured four balconies that enclosed the structure from east to west. A narrow gauge railroad up Lookout Mountain brought visitors to its doorstep where they were treated to guest rooms each with its own bath. In 1902, President Teddy Roosevelt was one such visitor. Photograph by the Hardie Brothers (ca. 1895)

The Stanton House was a handsome hotel built in 1871, shortly after the Civil War ended. Bostonian John C. Stanton was a carpetbagger who hoped to make the hotel a stop on a railway that he backed. In 1906, it was removed to make way for the Terminal Station, today a hotel known as the Chattanooga Choo-Choo. (1895)

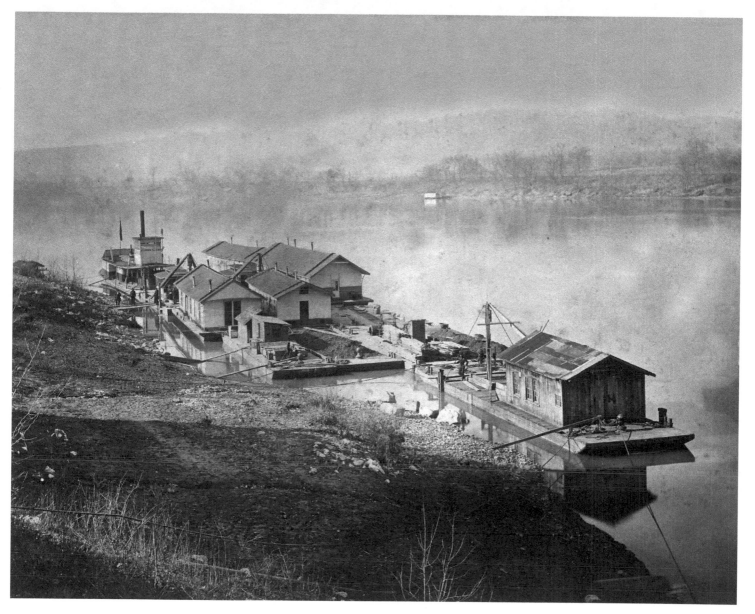

A fleet of houseboats docks at Ross's Landing in January 1897. With the *Stephen H. Long* in the rear the group appears to be headed upstream. The stone pillar of the Walnut Street Bridge is visible to the extreme right.

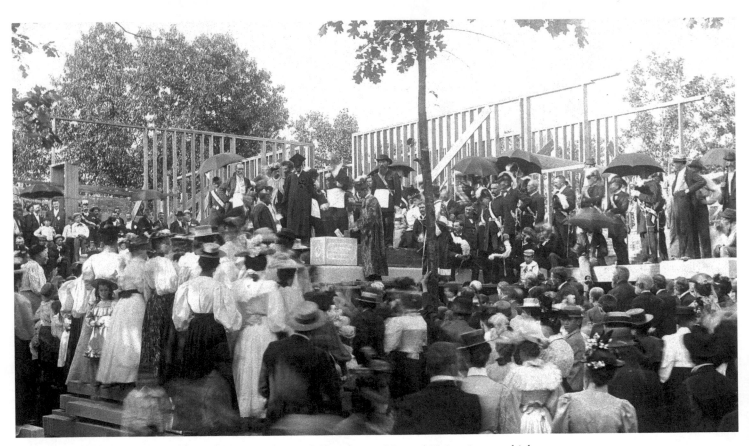

A crowd gathers to watch the laying of the cornerstone of Chattanooga Normal University on a high hill on Mississippi Avenue in 1896. Normal Park Elementary School was erected on this site in 1938 and still serves as a museum and magnet school today.

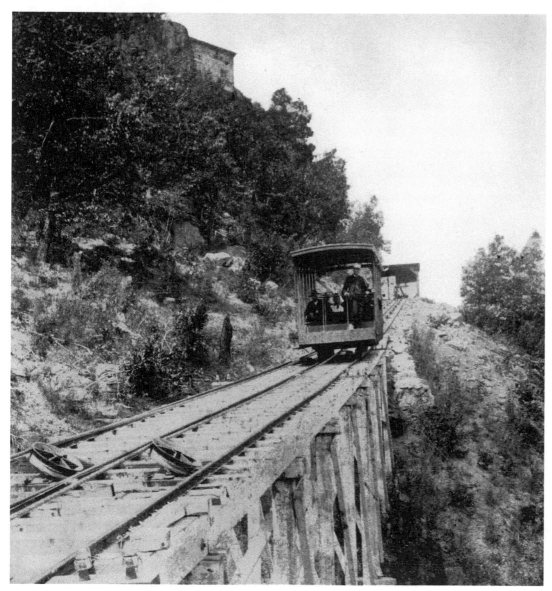

Following an economic boom in the 1880s and a yellow fever epidemic in 1878, Lookout Mountain became an attractive place to visit. Two incline railways would be built up the eastern side of the mountain to facilitate trips to enjoy the scenic beauty of the mountain. (ca. 1898)

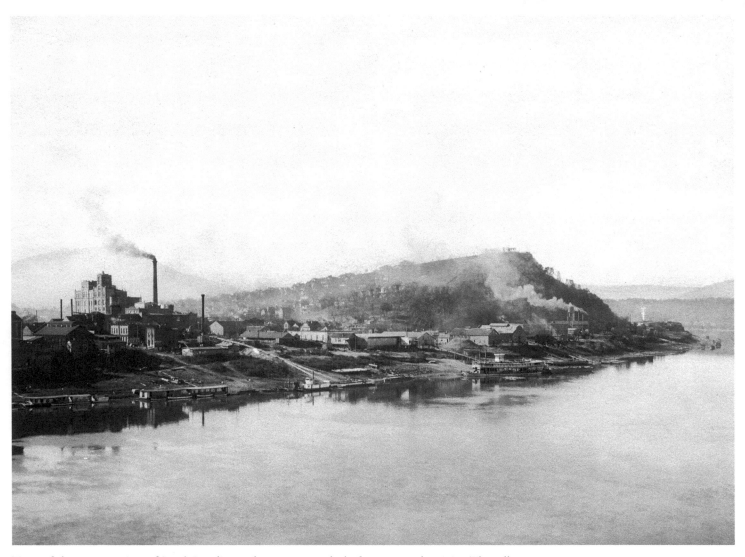

Turn-of-the-century view of Ross's Landing indicates a great deal of commercial activity. The tall building to the left is the Chattanooga Brewing Company. Private residences on Cameron Hill are visible at center. Photograph by William Stokes (ca. 1900)

At the Turn of the Century

(1900–1917)

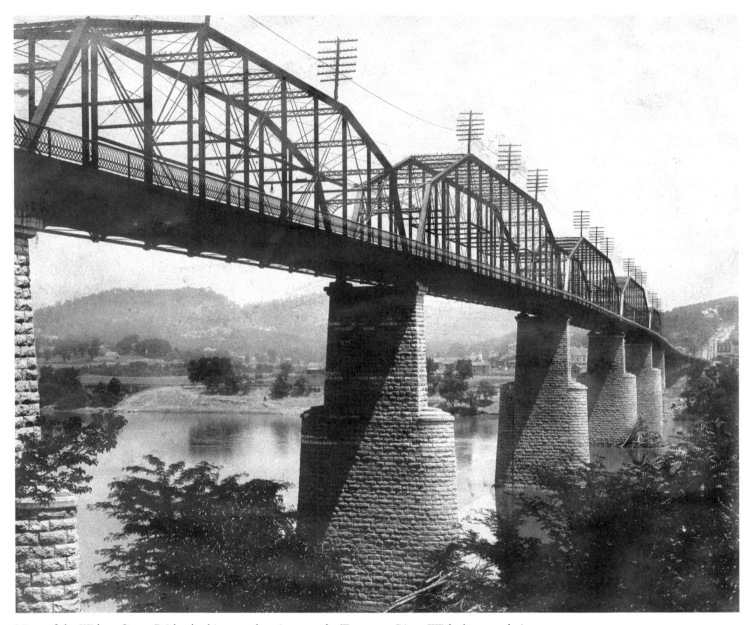

View of the Walnut Street Bridge looking north as it spans the Tennessee River. With the completion of the bridge in 1891, telephone poles placed atop the span made connections possible between Chattanooga and Hill City on the north side of the river. (1900)

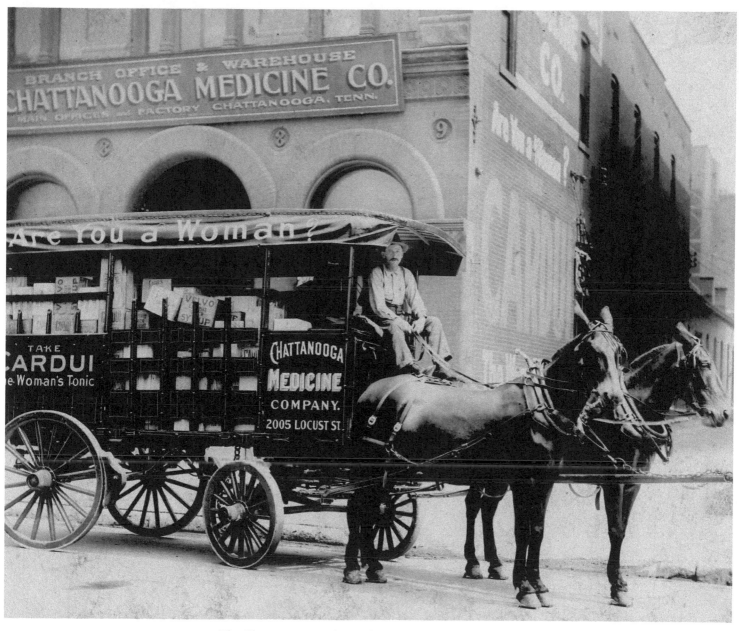

The Chattanooga Medicine Company, now known as Chattem, began in 1879 with two products. This wagon is filled with Dr. McElree's Wine of Cardui, a tonic for women, and Black Draught, a laxative. (ca. 1900)

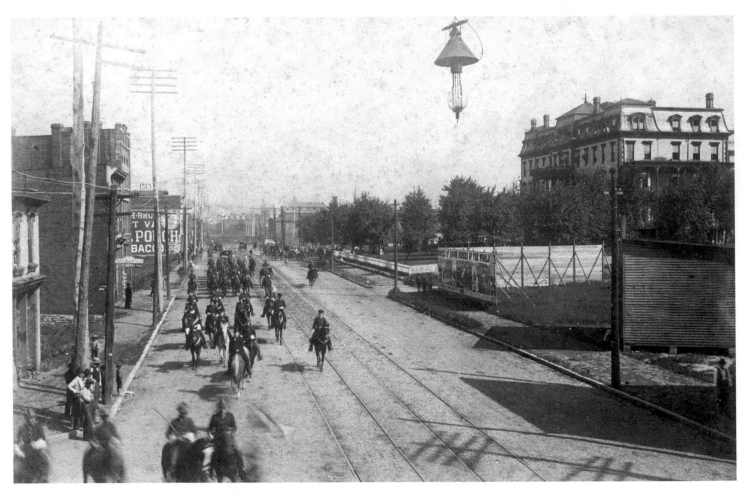

Mounted soldiers on parade pass the Stanton House on Market Street. Even though the luxurious hotel featured an observatory and other amenities, it was dismantled in 1906 and replaced with the Terminal Station in 1909. (ca. 1902)

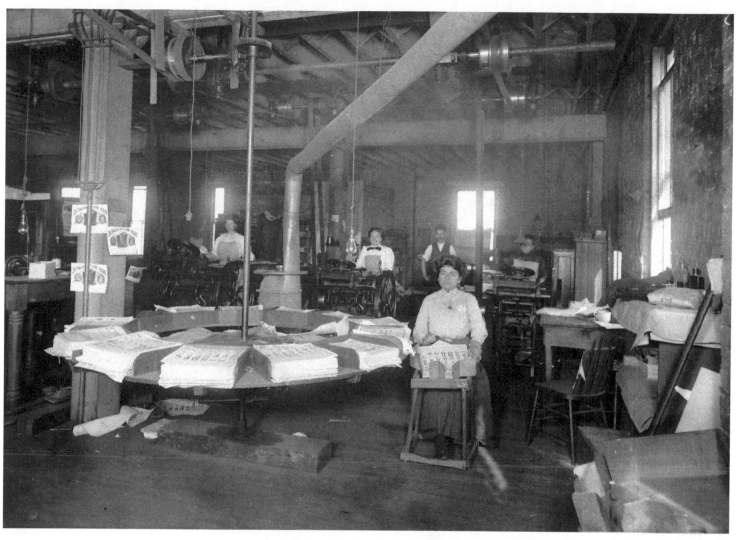

Women at Thacher Medicine Company assembling calendars. The company was known for a number of products including a "Liver and Blood Syrup" that "makes lazy livers lively." (ca. 1902)

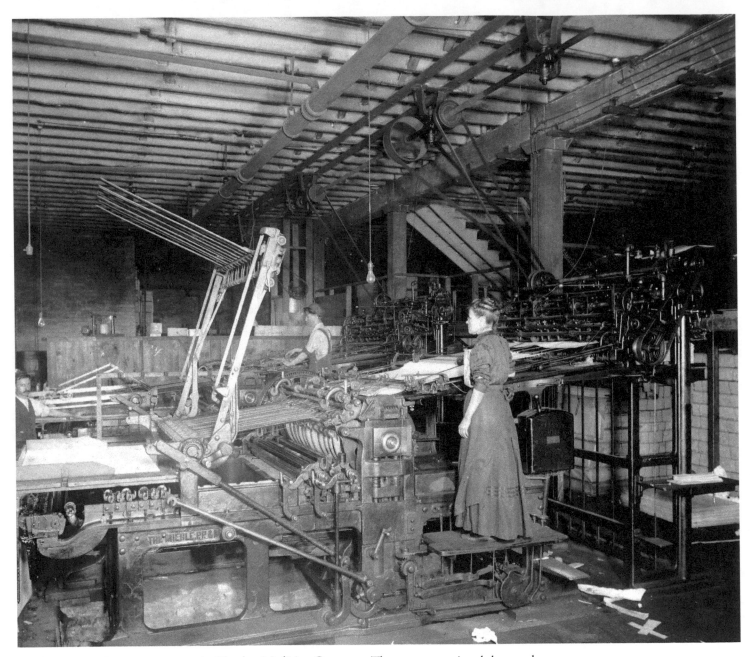

Workers in printing press room at the Thacher Medicine Company. The company printed thousands of calendars and almanacs every year laden with advertisements and health advice. (ca. 1902)

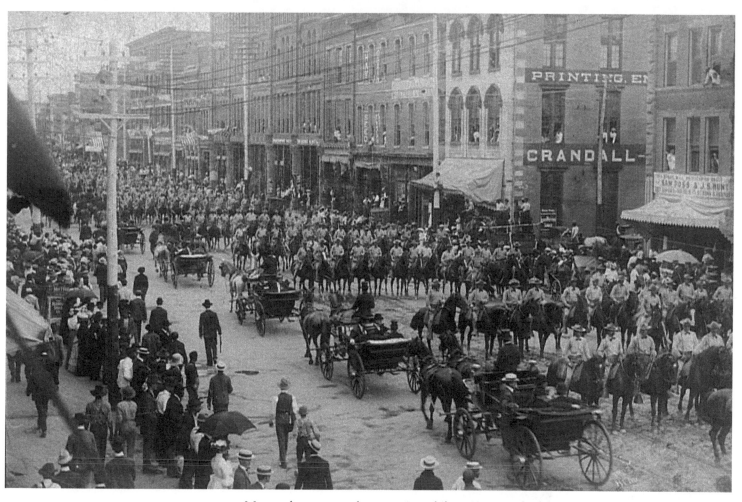

Mounted troops stand at attention while carriages with observers travel past them. This grand parade honored President Teddy Roosevelt's visit to the city. (September 1902)

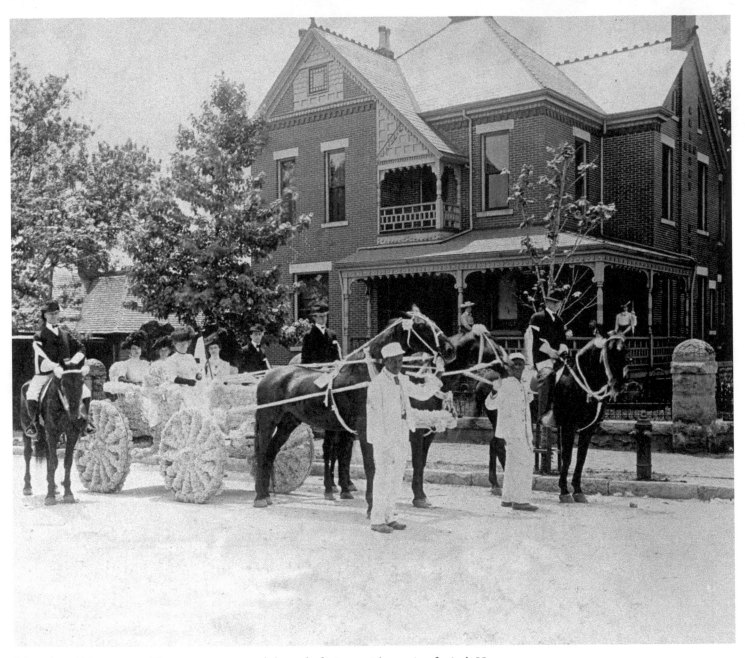

More than 100 years ago, Chattanoogans greeted the end of winter with a spring festival. Here a lavishly decorated trap waits in front of the F. Allen Gentry home at 201 High Street. (1902)

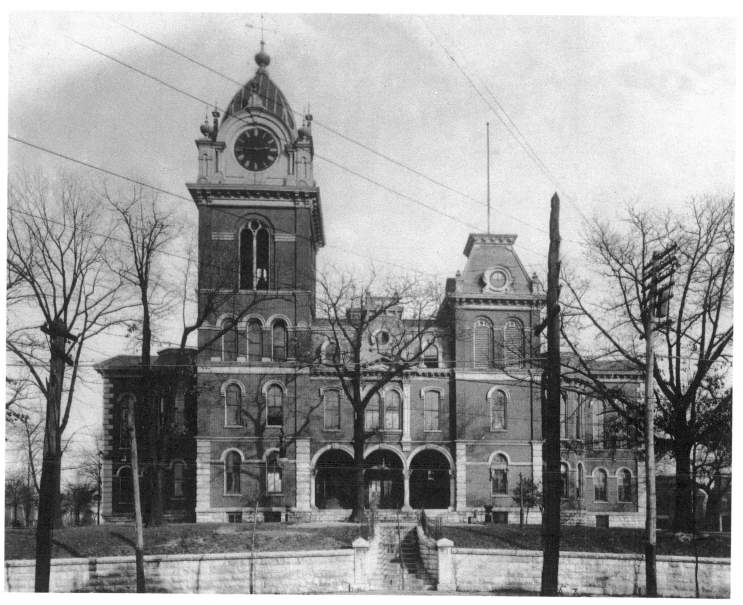

The afternoon sun shines on the Hamilton County Courthouse with its prominent clock tower. Built in 1879 after Chattanooga became the county seat, it was destroyed by a lightning strike in 1910. Photograph by Matt L. Brown & Co. (ca. 1900)

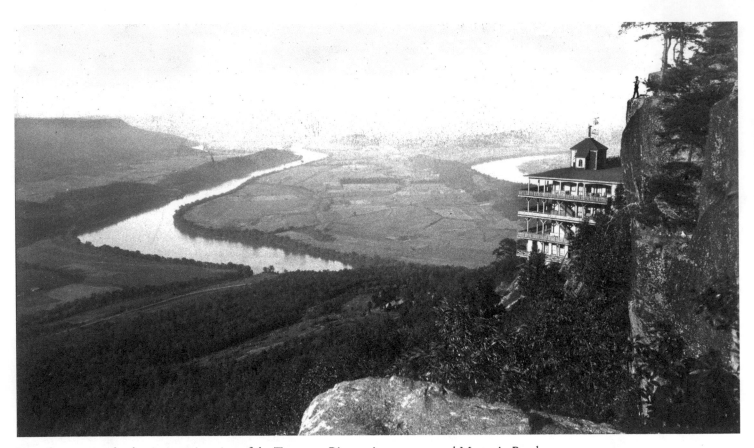

Lone figure on rock takes in stunning vista of the Tennessee River as it curves around Moccasin Bend.
To the right is the Point Hotel.
Photograph by J. B. Linn (ca. 1905)

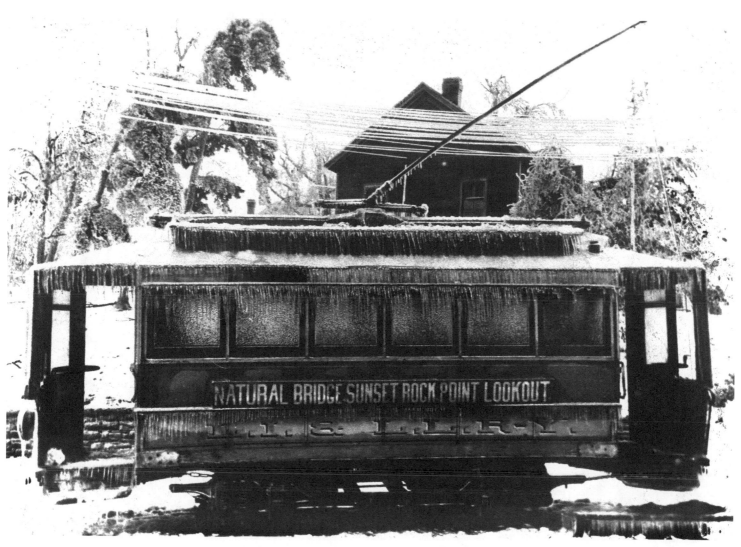

On February 5, 1905, a winter storm that hit Chattanooga was so severe that streetcar service was suspended for the first time in the city's history. Large blocks of ice were reported floating down the river. In this photograph a frozen Lookout Mountain Incline and Lula Lake Railway streetcar is blanketed with icicles.

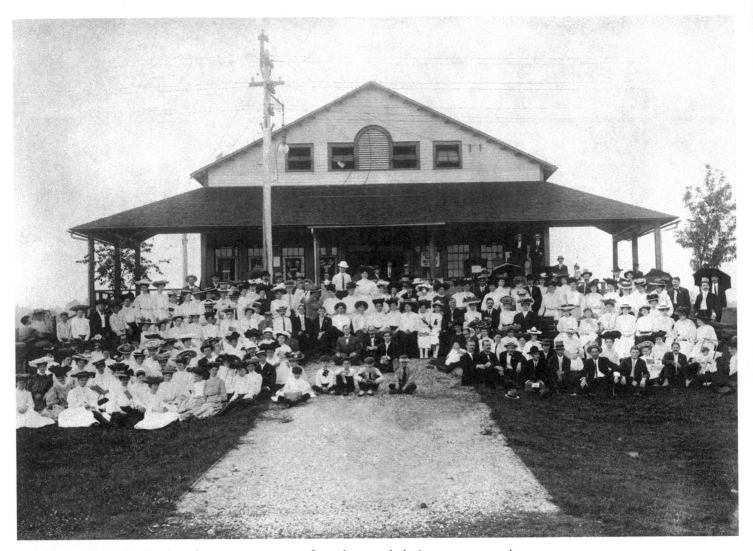

Employees of the Miller Brothers department store pose for a photograph during a summer outing at Olympia Park in June 1905. A popular location for gatherings, the newly established Olympia Park was purchased by the City of Chattanooga in 1912 and renamed Warner Park in honor of Commissioner Joseph H. Warner.

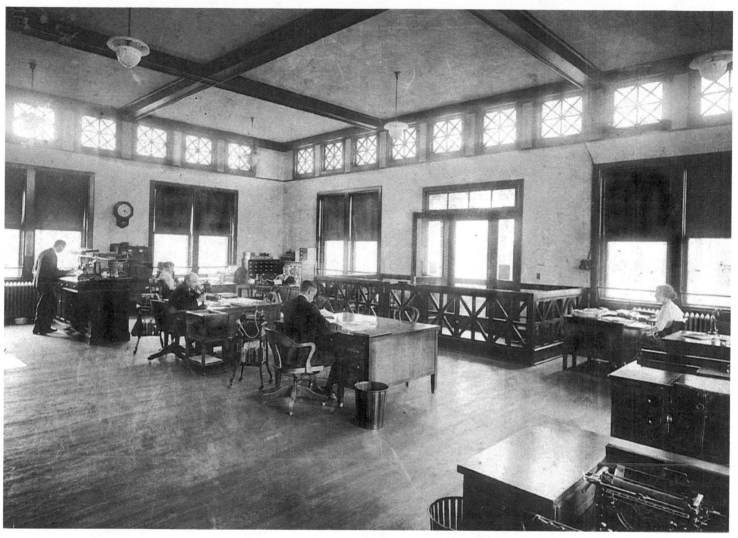

Another day at the office around 100 years ago. The workers at the Chattanooga Implement Company have plenty of light, room, and at least one working telephone. (1905)

The impressive Romanesque-style First Baptist Church stood at the corner of Georgia Avenue and Oak Street for 80 years. Designed by Chattanooga architect R. H. Hunt, it was built in 1887 with a bell tower that housed a one-ton bronze bell. (1906)

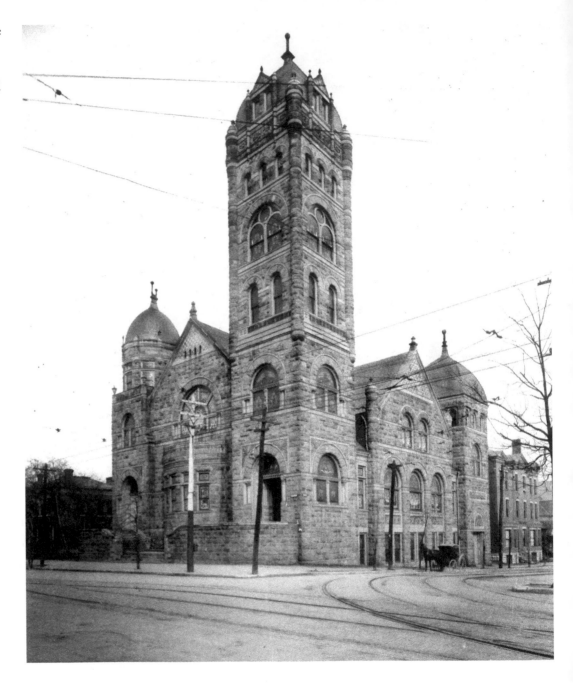

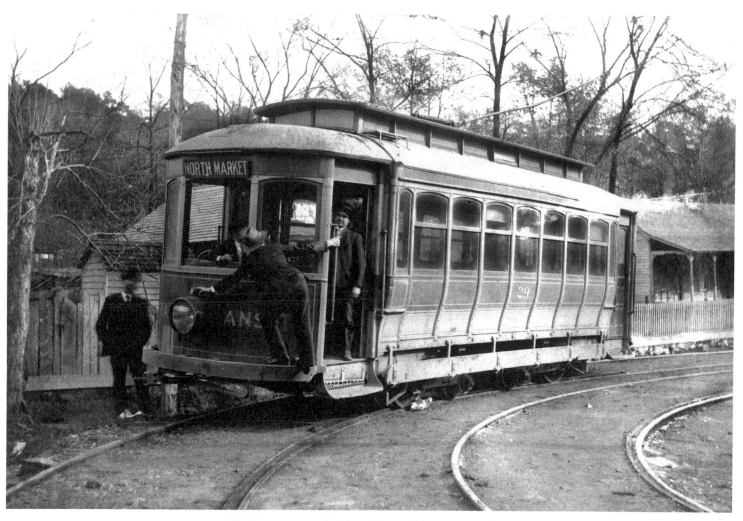

Streetcars were a familiar sight to Chattanoogans from 1875 until 1947, when buses became the standard mode of public transport. Route sign on this car reads "North Market," indicating this car is headed to North Market Street in Hill City. (ca. 1908)

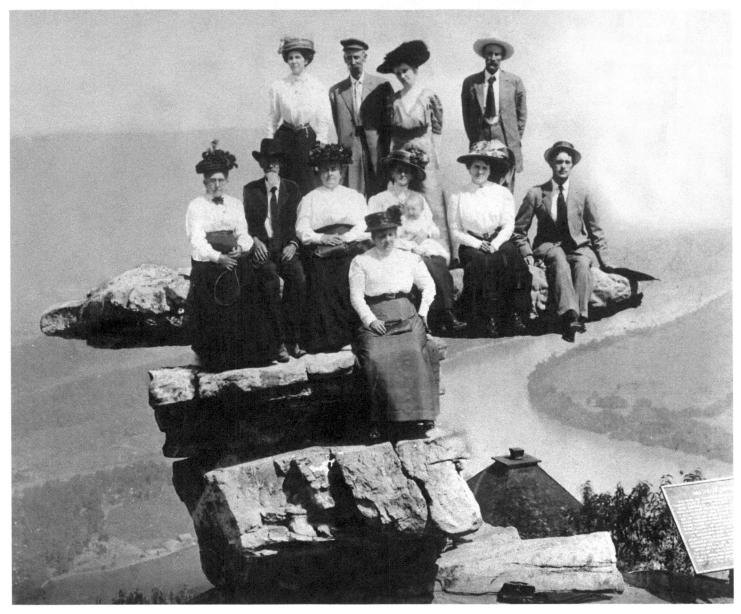

The ever-popular Umbrella Rock has hosted a potpourri of groups over the years. Here a group of Edwardian ladies and gentlemen pose for a photograph in August 1909. The roof of the Point Hotel is visible to the lower right of the photograph.

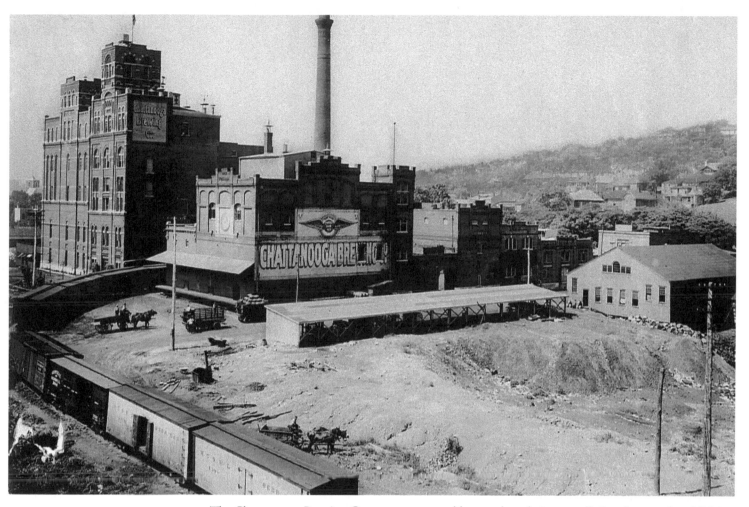

The Chattanooga Brewing Company concocted beer and made ice as well. But the era of prohibition made business difficult, and the brewery, which occupied a whole city block, closed in 1919 after forty years of fermenting. Eventually the Coca-Cola Bottling Company would establish its downtown operation on this site. (ca. 1910)

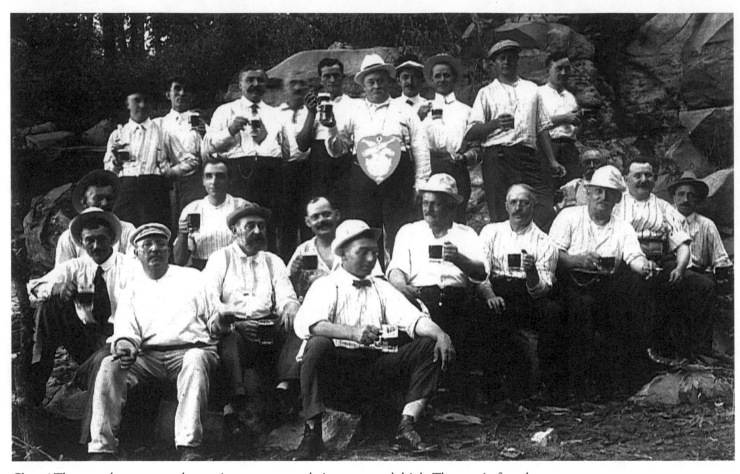

Cheers! These gentlemen are ready to enjoy some camaraderie over a good drink. The man in front has evidently started before the others.

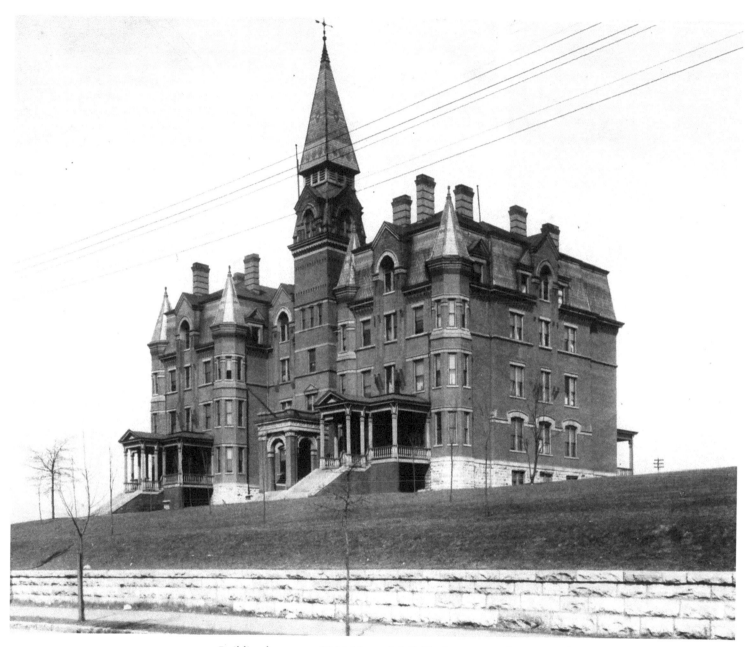

Building known as Old Main on McCallie Avenue was the center of Grant University, which would become the University of Chattanooga. Opened in 1886, it was taken down in 1917.

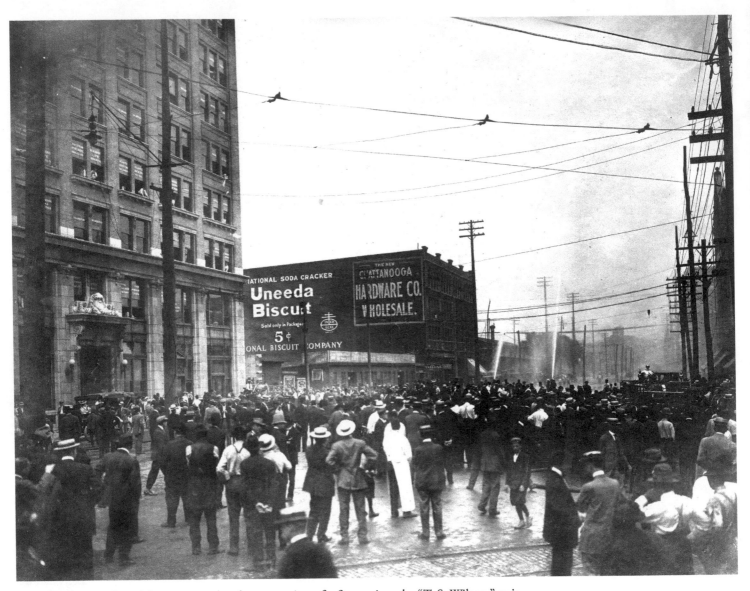

Crowd gathers on Broad Street to watch a demonstration of a fire engine, the "T. S. Wilcox," as it shoots jets of water into the sky. To the left stands the James Building, built in 1906. (June 1910)

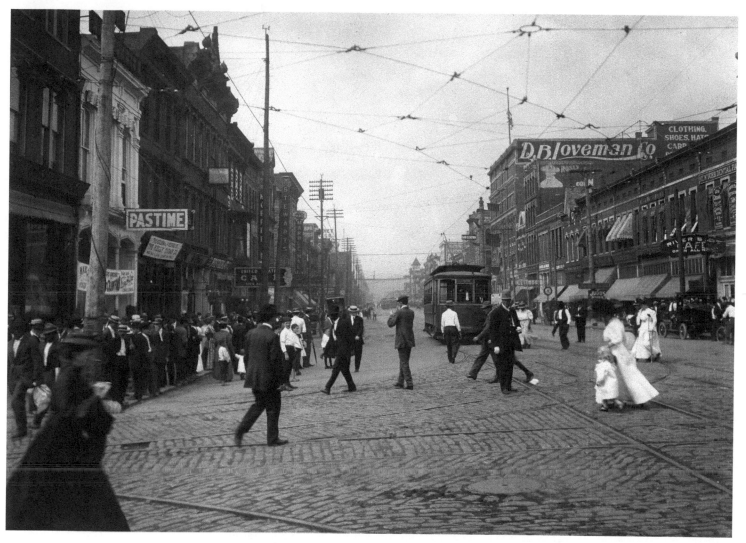

View of a busy day on Market Street as men, women, and children move ahead of an oncoming trolley. One of Chattanooga's finest department stores, Lovemans, is visible to the right in this photograph of the downtown business district looking north. (1909)

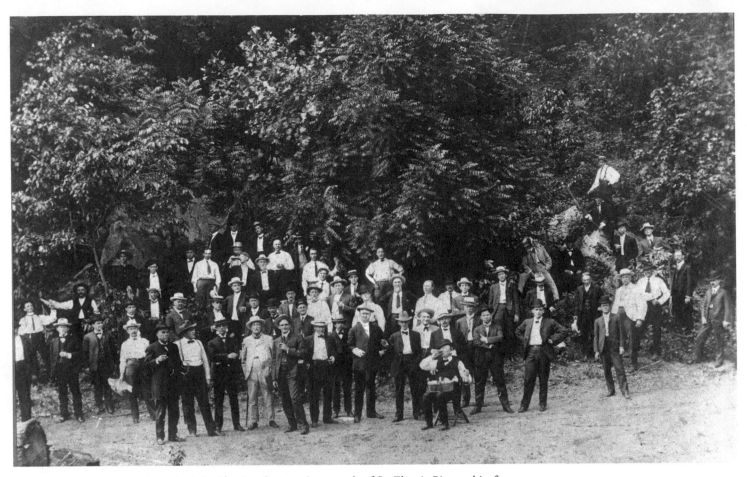

Chattanooga Bar Association Picnic in Blowing Springs (just south of St. Elmo). Pictured in front row, third from left is Alexander "A. W." Chambliss, and ninth from left, James Burnet "J. B." Sizer, attorneys with Chambliss, Bahner and Stophel. A. W. Chambliss, who founded the firm in 1886, was four-time former Chattanooga mayor, as well as Tennessee Supreme Court justice (1924) and chief justice (1947). J. B. Sizer joined the firm in 1910. (ca. 1910)

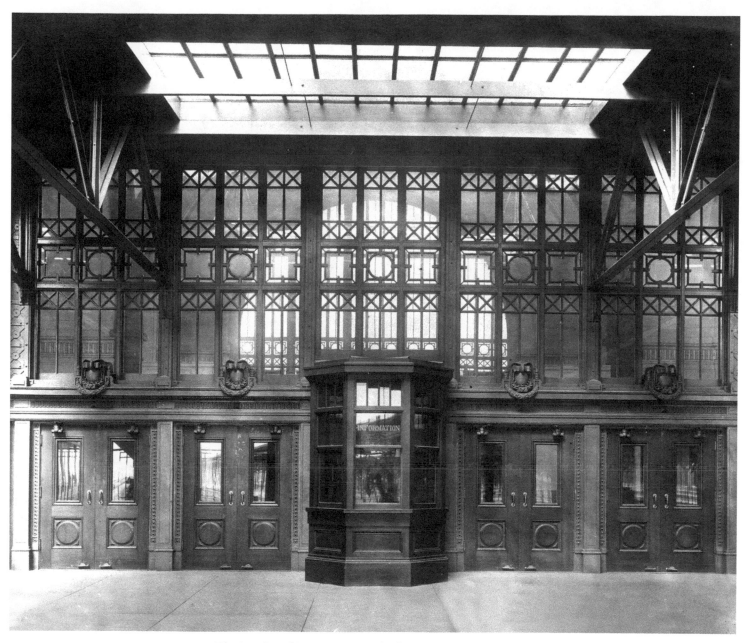

The interior of Union Station which greeted rail travelers was spacious and beautifully crafted. Light from the skylight above accentuated the architectural details of fine walnut and marble. (ca. 1910)

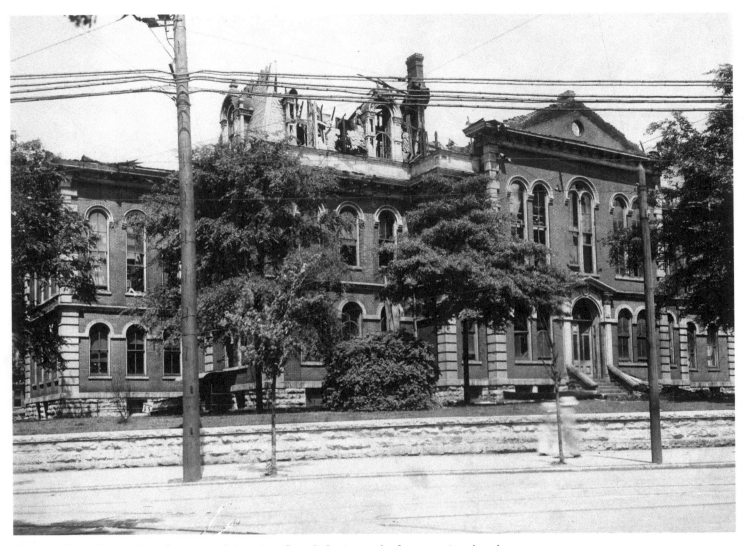

The Hamilton County Courthouse stands in ruins after a lightning strike from a spring thunderstorm set it ablaze. Located at the corner of Walnut and 7th streets, it was replaced with the current courthouse. Photograph by Stokes-Forstner (May 1910)

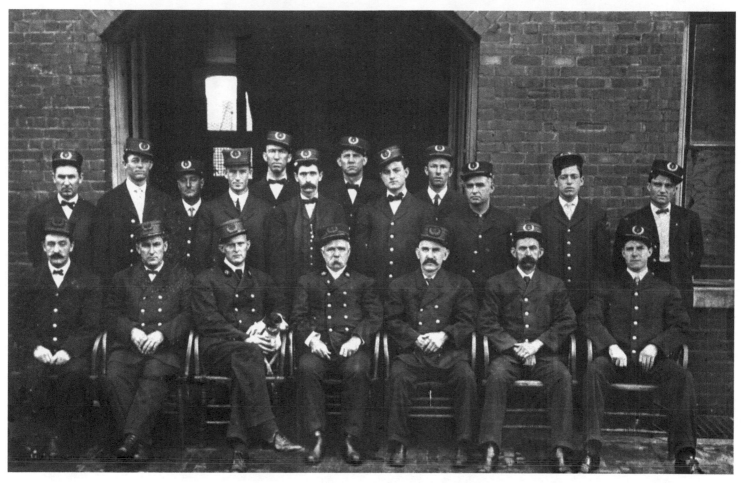

Chattanooga fire fighters in front of Fire Station No. 1 at 1033 Carter Street. Chattanooga's early fire fighters were organized by the Union army because of the large number of wooden buildings the troops erected during their occupation of the city.

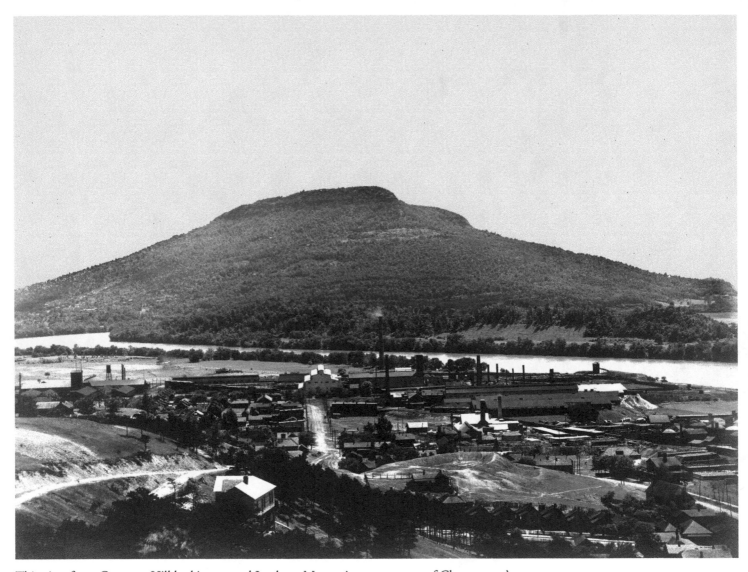

This view from Cameron Hill looking toward Lookout Mountain captures one of Chattanooga's early industrial settings. The land west of Cameron Hill was developed by Union army engineers to build rolling mills and other production facilities to aid the war effort. This land continues as a manufacturing site today. (ca. 1910)

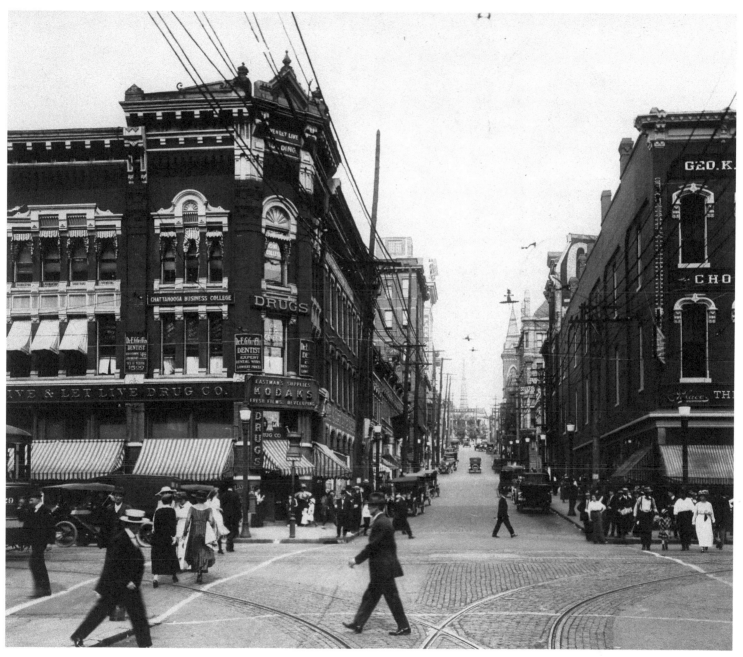

Street scene typical of Chattanooga circa 1910. Visible are the Live & Let Live Drug Company on the left and the George K. Brown Company on the right.

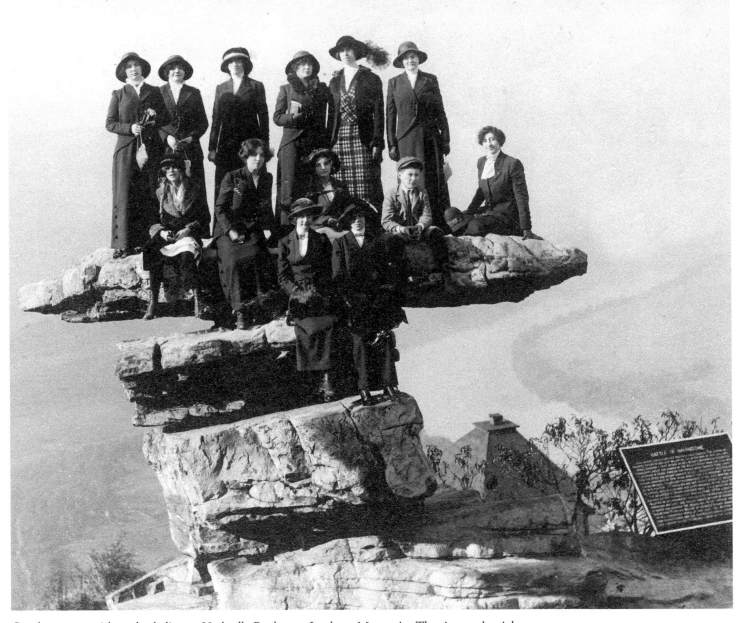

One boy poses with twelve ladies on Umbrella Rock atop Lookout Mountain. The sign to the right describes the Battle of Wauhatchie that took place in the valley below. The roof of the Point Hotel is visible next to the sign. (ca. 1912)

Wagons, automobiles, and trolleys are in evidence in this scene on Market Street looking north. (ca. 1914)

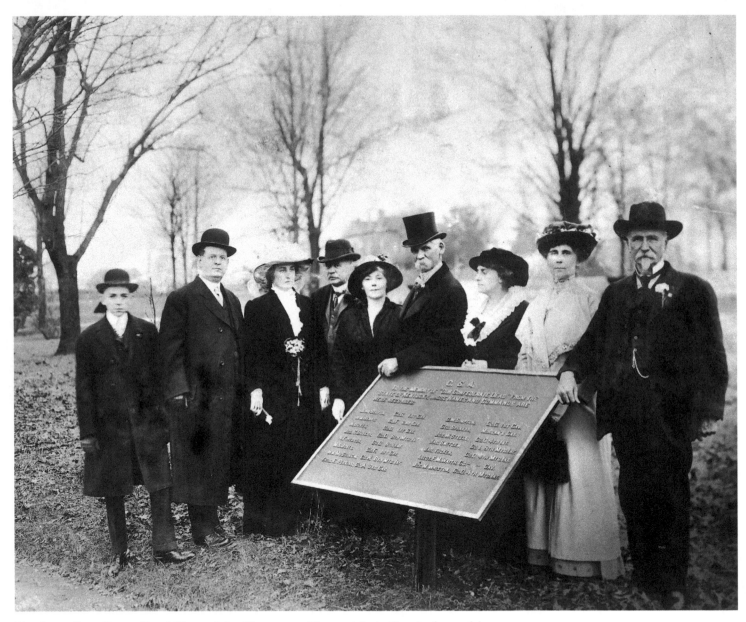

Two journalists, George Fort Milton of the *Chattanooga News* and S. A. Cunningham of the *Confederate Veteran,* stand with a proud group beside a marker at the Confederate Cemetery in Chattanooga. Visits to the cemeteries of the Confederate war dead were a common practice for many years. Photograph by W. H. Stokes (December 4, 1913)

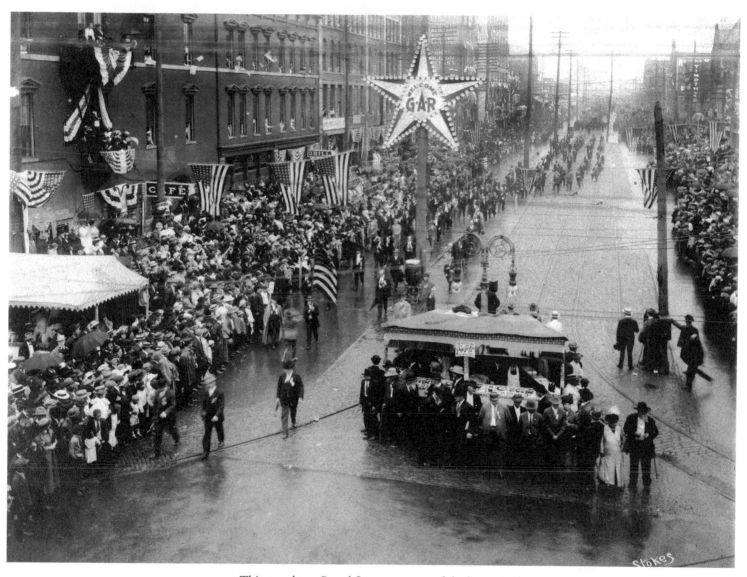

This parade on Broad Street was part of the large Civil War veterans' reunion that took place in Chattanooga in 1913. Since the battle at Chickamauga was 50 years in the past, this gathering would be the last for many of the blue and the gray. (September 17, 1913)

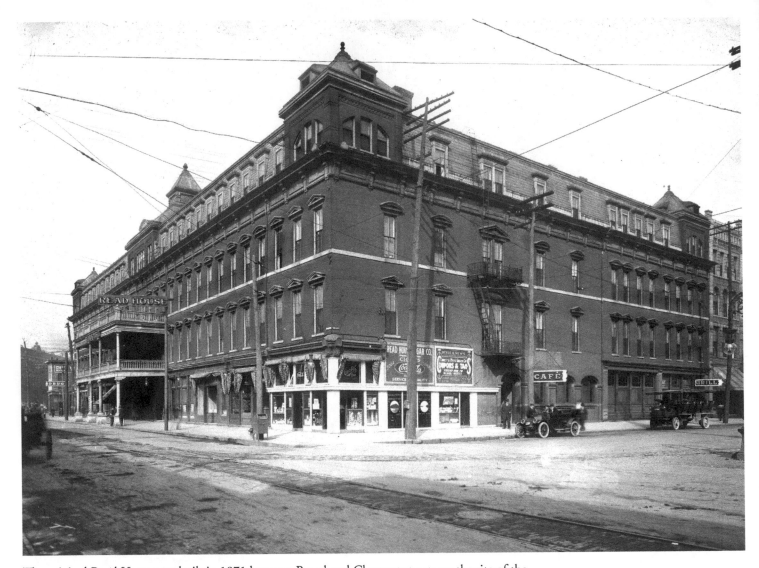

The original Read House was built in 1871 between Broad and Chestnut streets on the site of the Crutchfield House. The balcony on the side faced the Union Depot. An electric sign is visible on the same side. Photograph by Stokes-Forstner (1914)

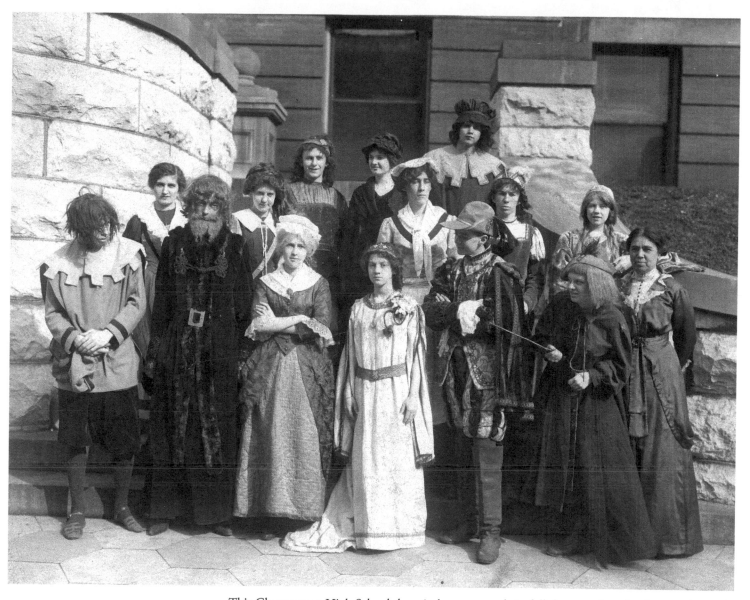

This Chattanooga High School theatrical group stands in full dress on the school steps. Certainly a great deal of energy was spent on the varied costumes, which suggest the performance of a Shakespearean play. (1914)

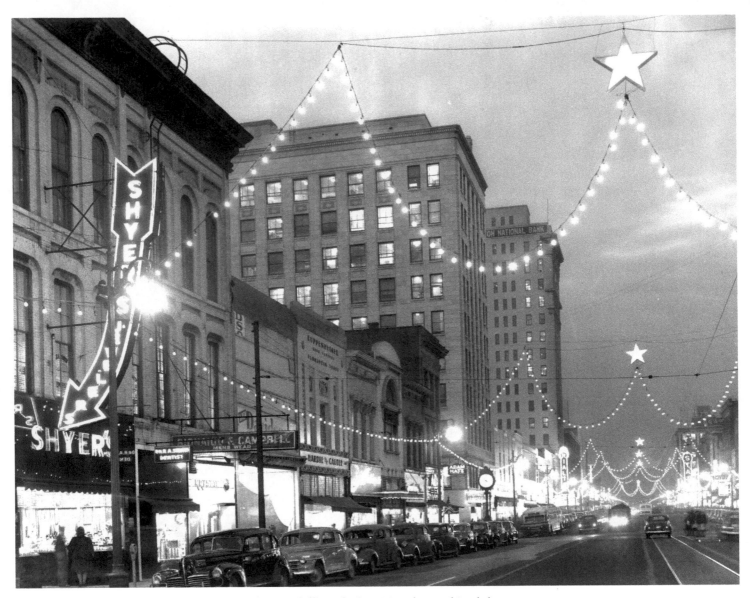

Circus promoters stand in front of a Stoops Company billboard advertising the combined shows of Hagenbeck and Wallace. Headliners include the Candy Kid and Floppie, "the original juggling equestrian sea lion." (ca. 1915)

THE FIRST WORLD WAR AND A GROWING METROPOLIS

(1918–1939)

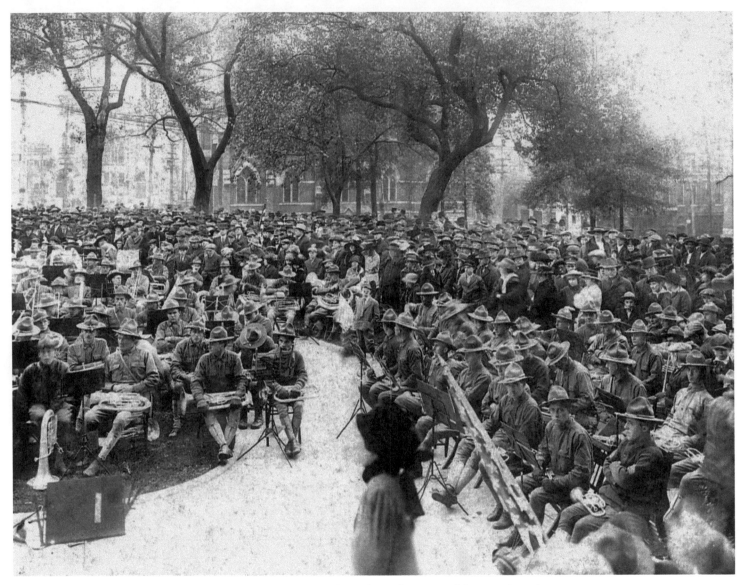

U.S. Army Mass Band concert on the Hamilton County courthouse lawn during World War I. (1918)

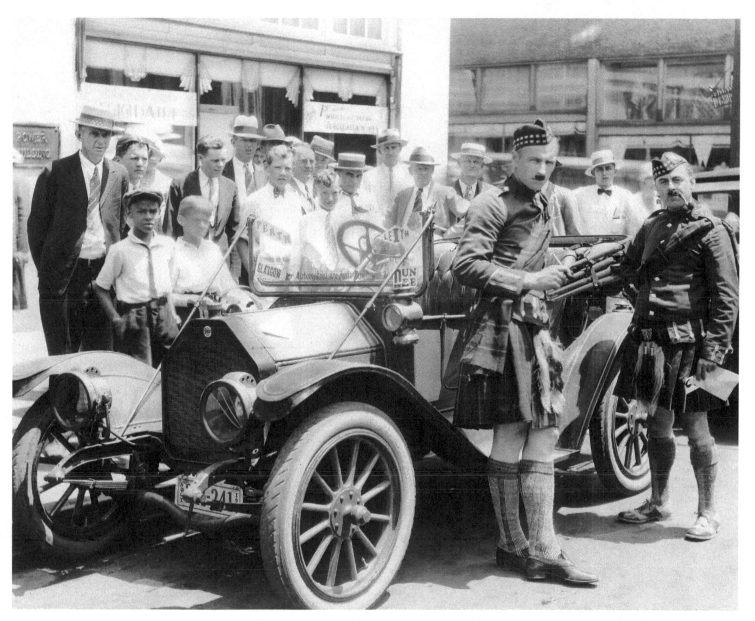

Two Scotsmen pose with their automobile outside the Electric Power Board building. Automobile events, often sponsored by the Dixie Highway Association, were popular ways to promote the need for good roads in Tennessee.

(ca. 1919)

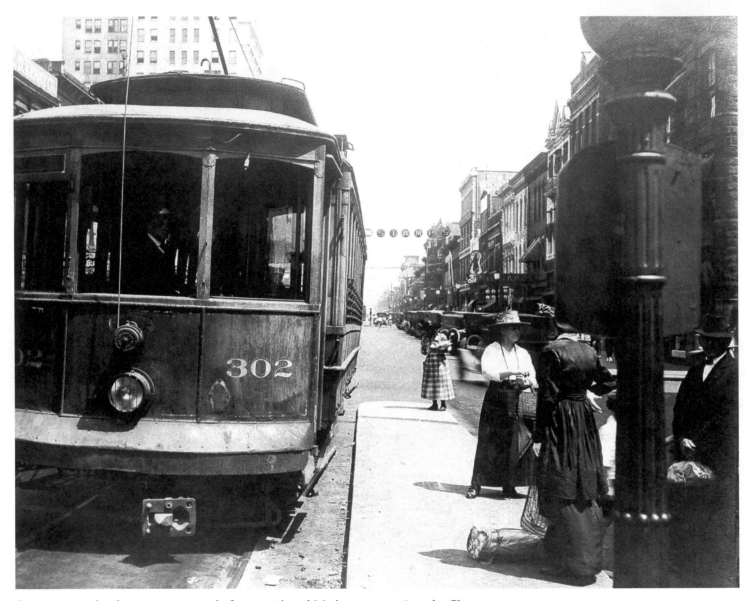

On a summer day three women on a platform at 8th and Market streets wait as the Chattanooga
Railway and Light streetcar approaches.
Photograph by William Stokes (1919)

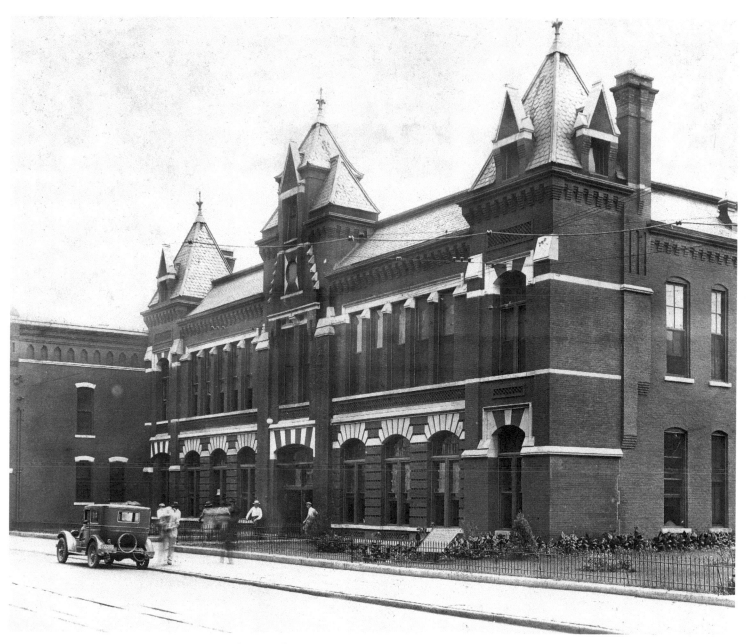

Located across the street from the Read House, Union Station signaled the importance of Chattanooga as a national rail center. This brick Victorian-style train station with slate roof was completed in 1882; it fell victim to the wrecking ball in 1973. (ca. 1924)

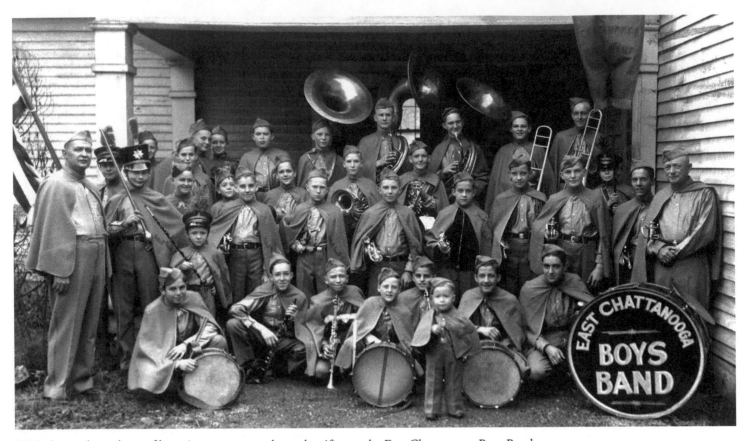

With three tubas, a bevy of brass instruments, and caped uniforms, the East Chattanooga Boys Band must have been a lively addition to any parade. (ca. 1925)

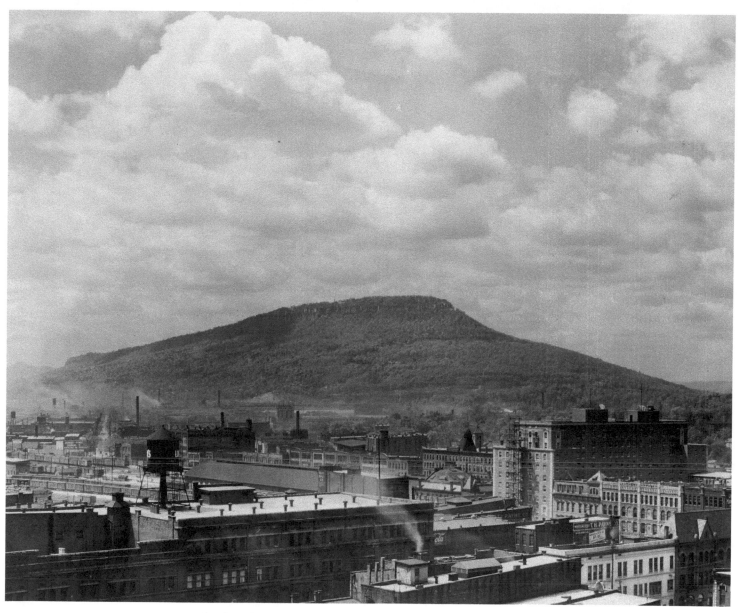

Lookout Mountain with its singular profile overlooks downtown Chattanooga. The tallest building to the right of center is the Read House; the many smokestacks to the left indicate the industrial section south of downtown. (ca. 1930)

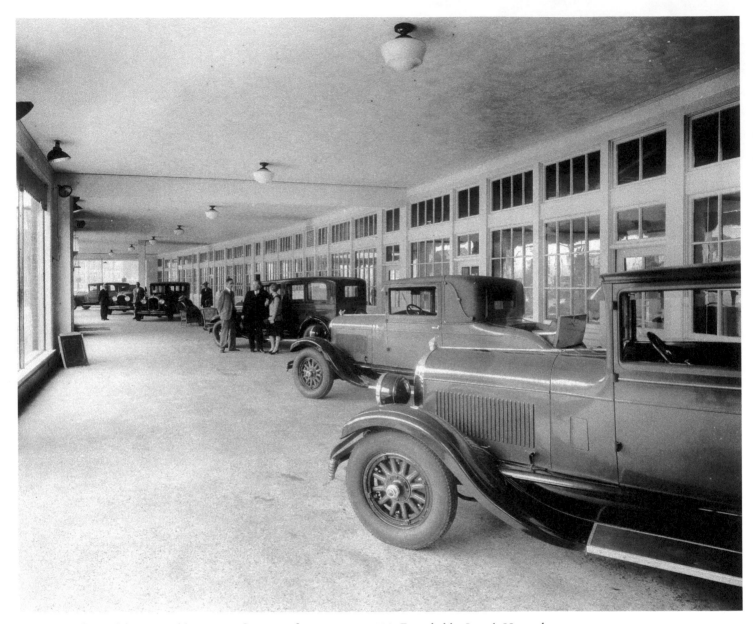

Showroom floor of the J. H. Alday Motor Company from 1928 to 1929. Founded by Joseph Howard Alday, the company sold Chrysler automobiles. (1928)

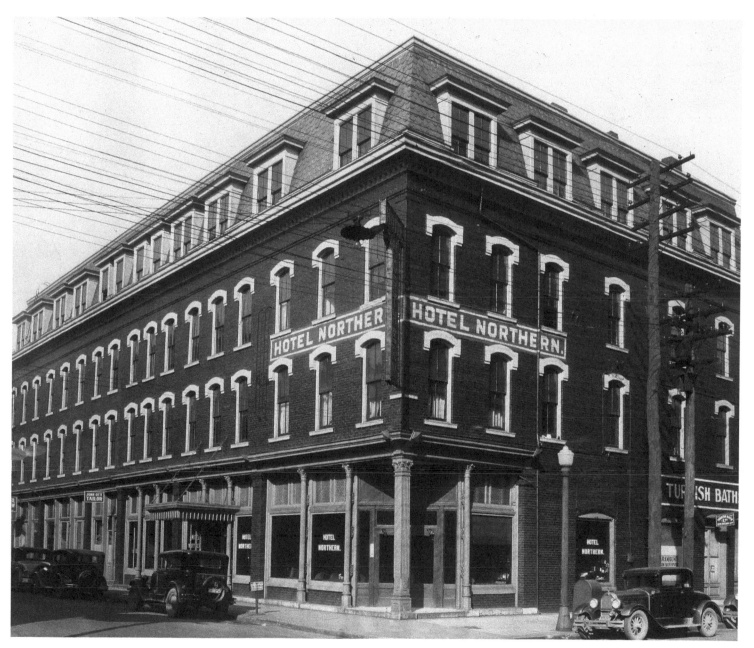

Built in 1886, the Hotel Northern was located at 8th and Chestnut streets. John Ott's tailor shop and a Turkish bath were two of the retail operations on the ground floor. (1928)

The Hotel Ross still stands today at Georgia Avenue and Patten Parkway. The hostelry was named after John Ross, the great Cherokee chief, who founded Chattanooga by establishing a ferry at Ross's Landing on the Tennessee River in 1815. (1928)

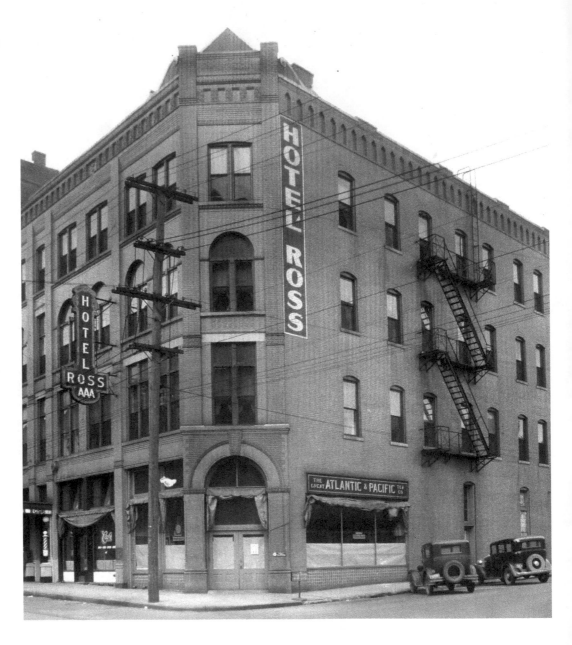

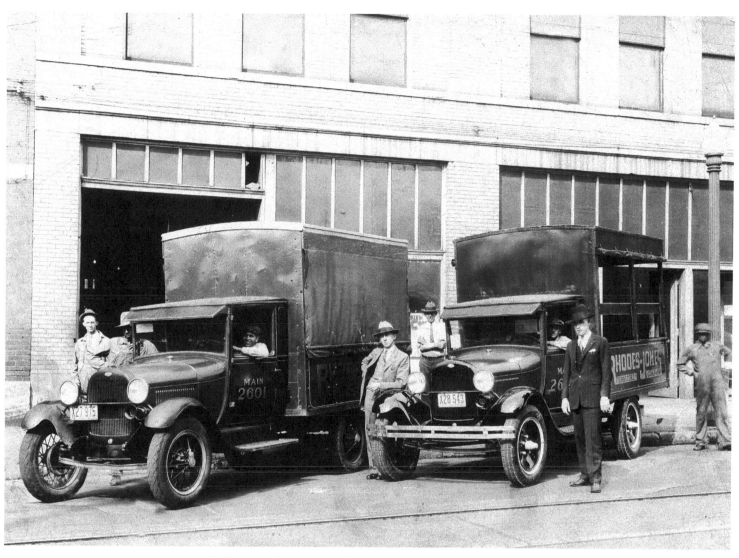

Delivery trucks wait outside Rhodes-Jones Furniture Store at 608 Market Street, where the store was located for twenty years from 1923 to 1943. (1929)

A blurry bicycle rider is visible in front of a Chattanooga landmark, the Read House. This ten-story building with its beautiful walnut-paneled lobby and terrazzo floor inlaid with marble was built in 1926, and replaced the original Read House that had stood on that spot since 1871. (1930)

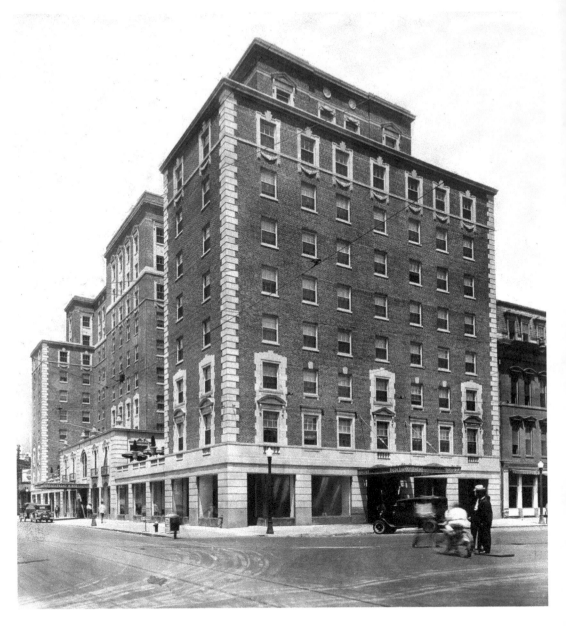

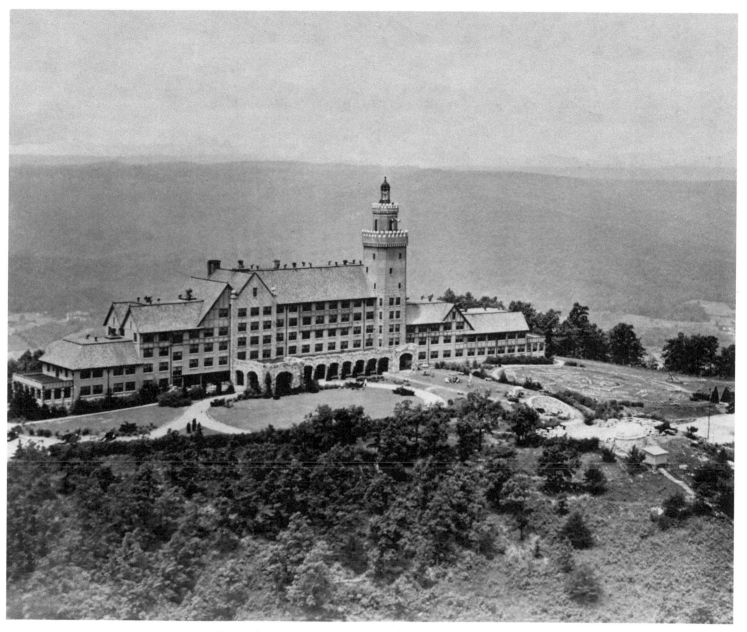

The Lookout Mountain Hotel was designed by Chattanooga architect R. H. Hunt and built by Paul Carter in 1927. Known for years as the "Castle in the Clouds," it became the campus of Covenant College in 1964. (ca. 1932)

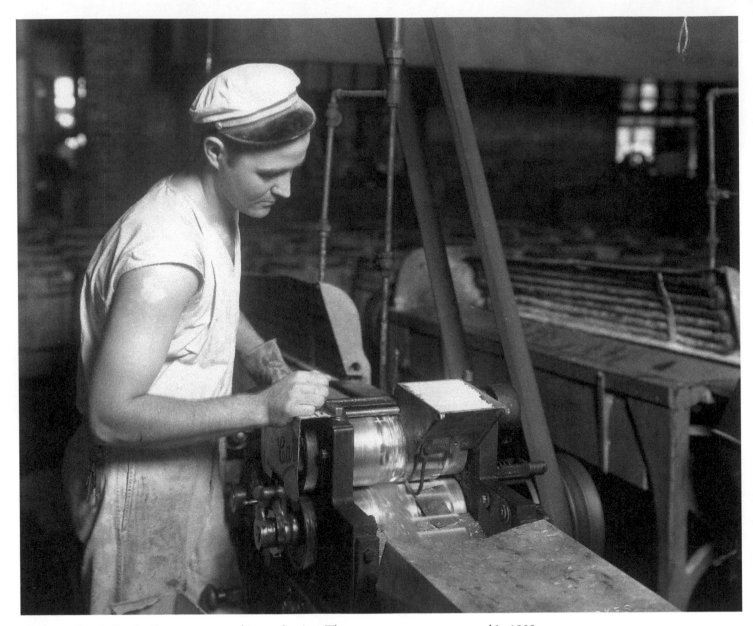

Worker at Brock Candy Company engaged in production. The sweets company was started in 1909 by William E. Brock, who would later become a U.S. senator from Tennessee. Two generations later his grandson, William E. Brock III, would be elected to the U.S. Senate from Tennessee. Photograph by William Stokes (1930)

Funeral hearses are parked on McCallie Avenue outside Bryan Funeral Home, the former residence of R. B. Davenport. Begun in 1929, the funeral company is one of the oldest in the region. (ca. 1932)

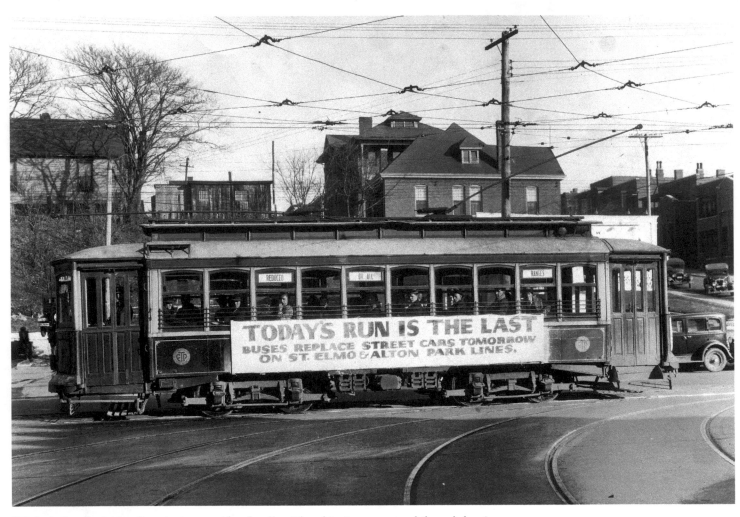

"Today's Run Is the Last" reads sign on side of trolley. The ubiquitous automobile and the city "motorcoach," or bus, were taking passengers from the trolley lines. (November 1932)

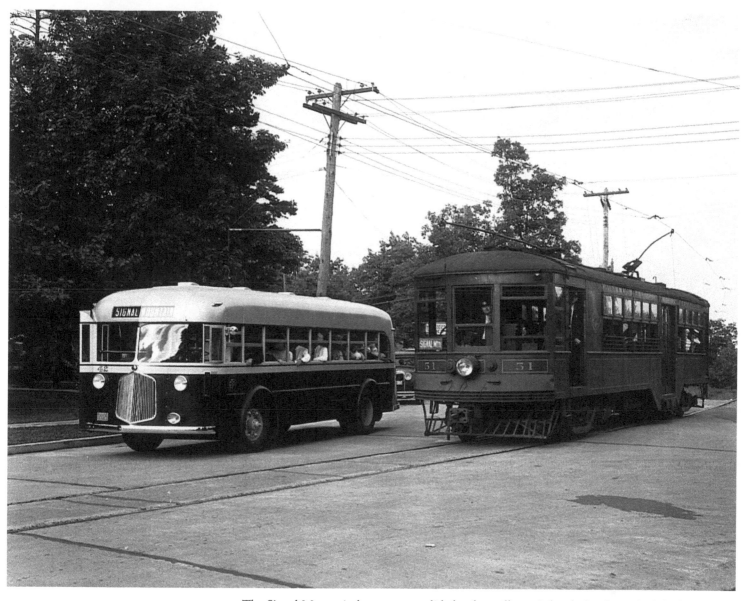

The Signal Mountain bus seems to glide by the trolley as it heads for the end of the line. Hugh Parks, trolley operator, directs Number 51 on its final day on the tracks. The following day the "ugly duckling" replaced the streetcar on this route. (July 4, 1934)

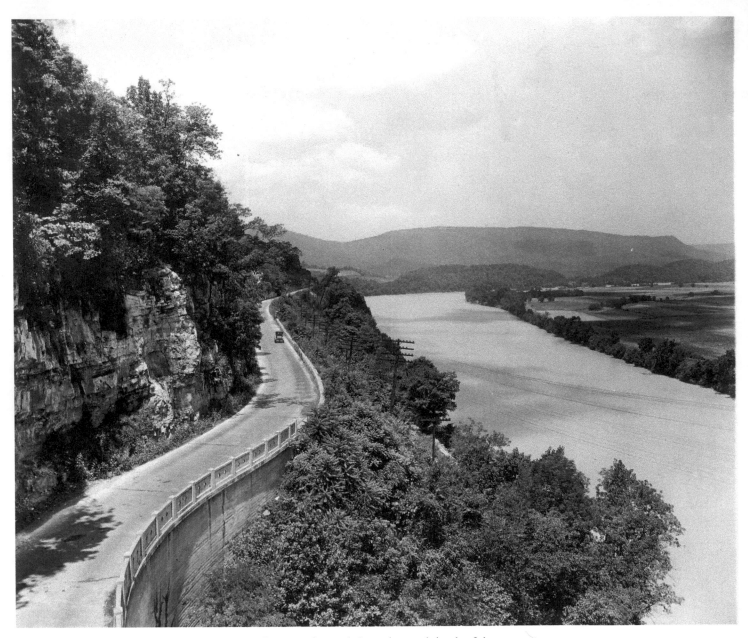

A solitary car drives on the Will Cummings Highway as the road skirts the south bank of the Tennessee River across from Moccasin Bend. The highway, named for the prominent judge in Chattanooga who helped promote road construction, opened in September 1930. (ca. 1932)

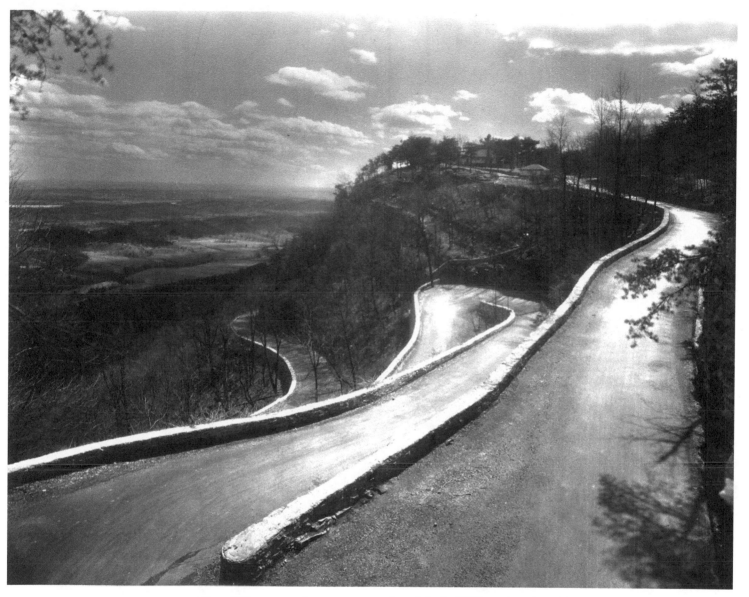

One of Chattanooga's most renowned roads is the "W" road on Signal Mountain, so named because of the shape of the switchback curves. Constructed in 1893 on the east side of the mountain, it followed a corduroy or log road used during the Civil War. In 1927, the road was widened, and mortared walls were put in place. Photograph by Cline (ca. 1930)

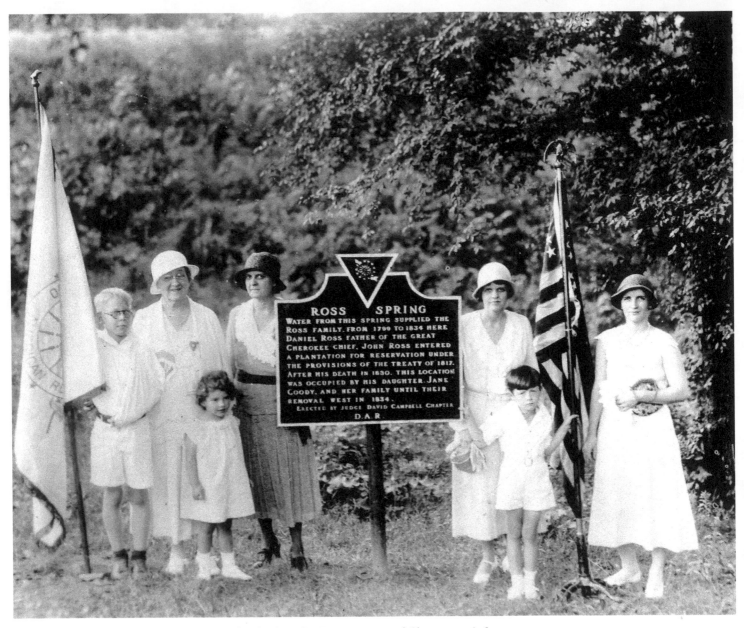

Daniel Ross, the father of the famed Cherokee leader John Ross, was one of Chattanooga's first recorded settlers. In this image, the Daughters of the American Revolution dedicate a plaque at the foot of Lookout Mountain to mark the spring where he lived. (1932)

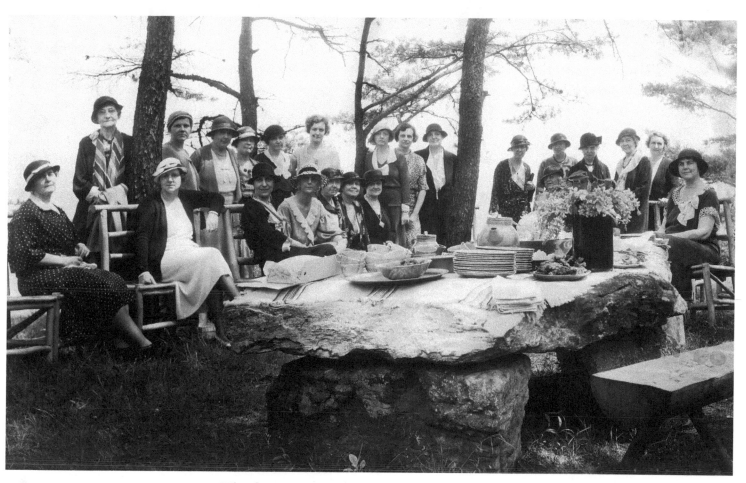

What finer way to spend an afternoon than to dine outside with good food and wonderful friends. The rock formations on the Chattanooga mountains can make convenient tables and the altitude serves as a deterrent to insects. (ca. 1930)

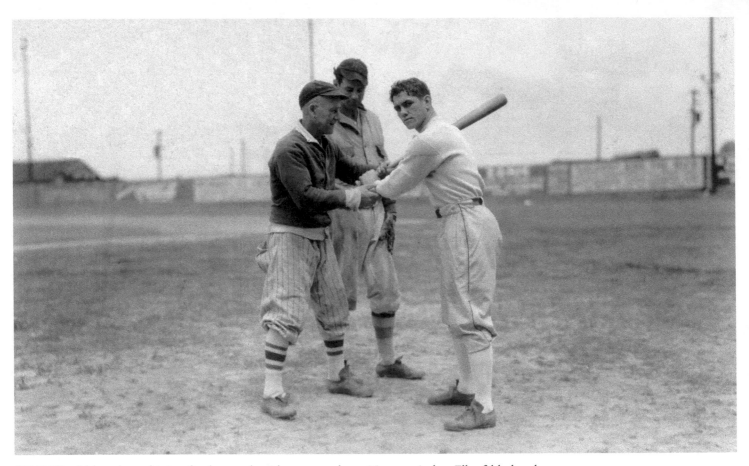

"Kid" Elberfeld works on hitting fundamentals with a young player. Norman Arthur Elberfeld played professional baseball with six teams including the New York Highlanders, who later became the storied New York Yankees. Known as the "Tabasco Kid," because of his fiery style of play, he was manager for the Chattanooga Lookouts on three different occasions. (ca. 1932)

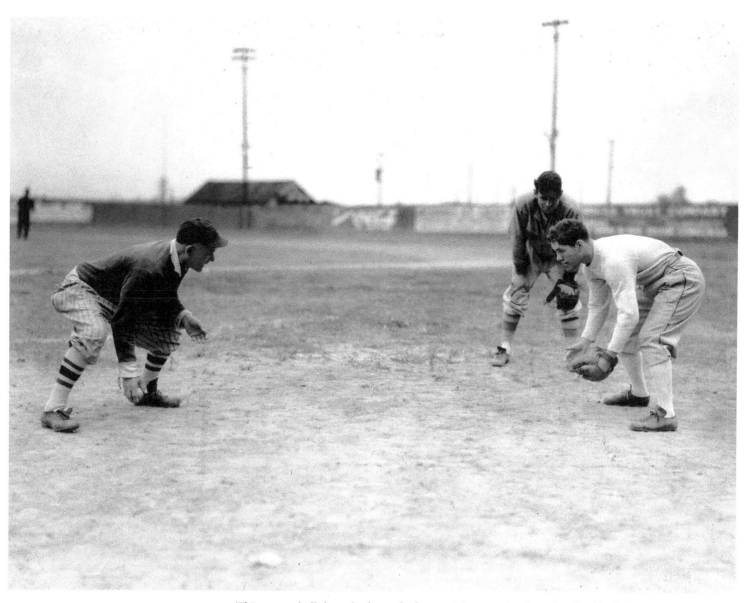

This young ballplayer looks ready for a quick grounder from "Kid" Elberfeld. The 5-foot 5-inch Elberfeld was known as a competitive, temperamental athlete, whose legs were badly scarred from his aggressive style of play. A manager for many years in the minors, he and his family made their home on Signal Mountain.

Chattanoogan Garnet Carter is generally credited with creating the first miniature golf course, which he called "Tom Thumb Golf." A master promoter, Carter organized a company to manufacture the courses with their obstacles in 1928, selling it a year later to an organization in Pittsburgh for a handsome profit. (ca. 1930)

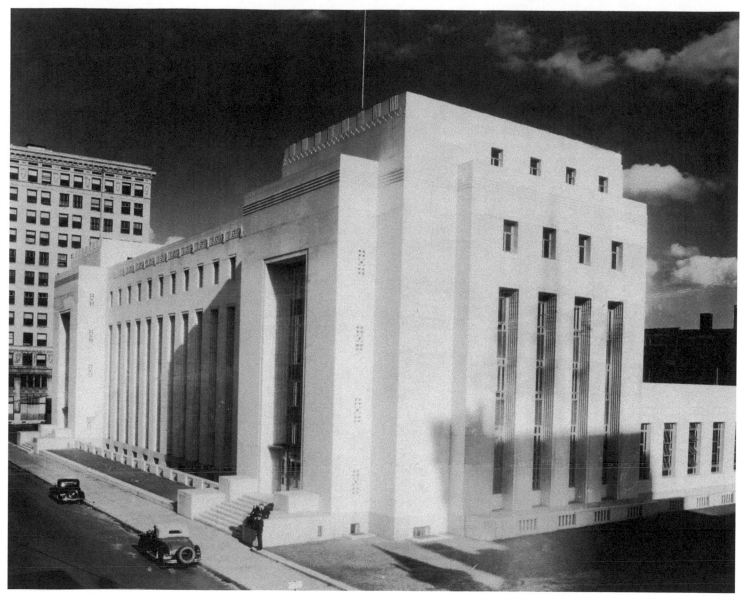

Chattanooga architect Reuben Harrison Hunt designed this fine building, known today as the Joel Solomon Federal Building. Finished in 1933 with an exterior of Georgia white marble and featuring impressive aluminum grillwork, the building contains a post office and federal courthouse. The interior includes a WPA mural as well as a courtroom that is trimmed out in myrtle. (1935)

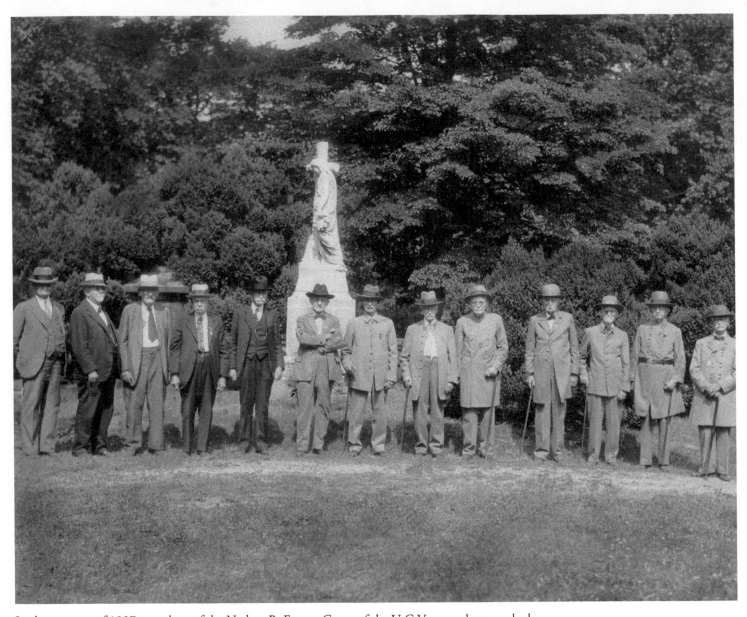

In the summer of 1937, members of the Nathan B. Forrest Camp of the U.C.V. were photographed at the Silverdale Cemetery. The cemetery was established primarily as a final resting place for 155 unknown Confederate soldiers who had perished in Chattanooga.

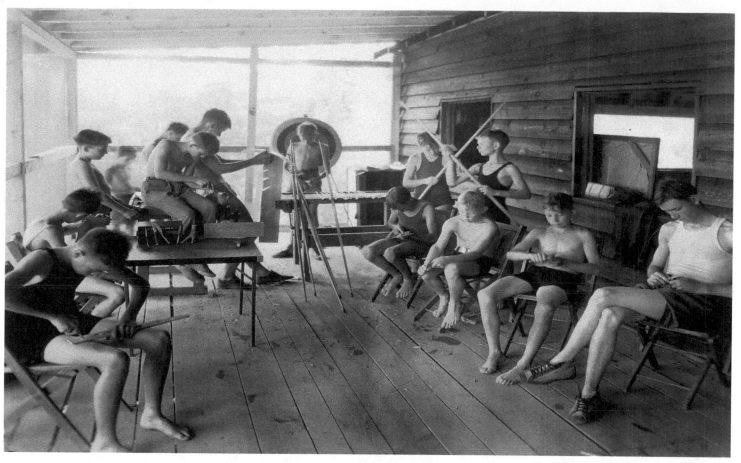

Working on a screen porch, summer campers seem deeply absorbed in woodcarving projects. The mountains around Chattanooga are home to many such woodland camps. (ca. 1936)

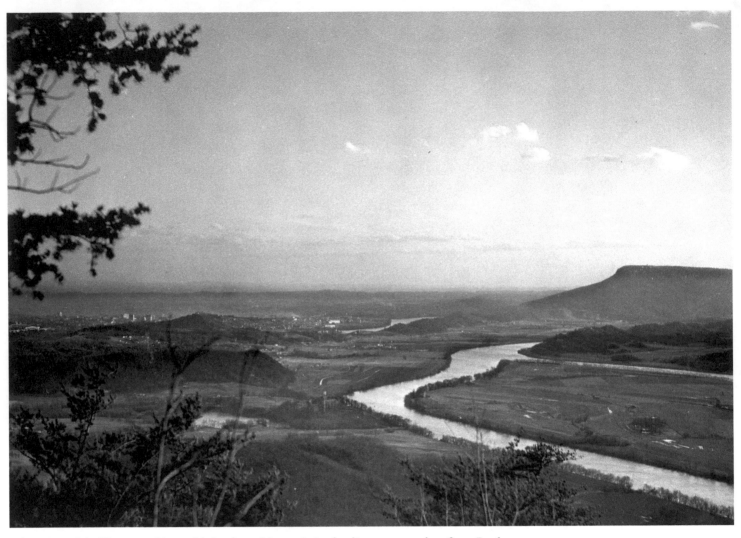

This view of the Tennessee River with Lookout Mountain in the distance was taken from Brady Point on Signal Mountain. The river winds around Williams Island, a site that archaeologists believe supported human habitation as far back as 5,000 years ago. (ca. 1938)

World War II Era to Recent Times

(1940–1960s)

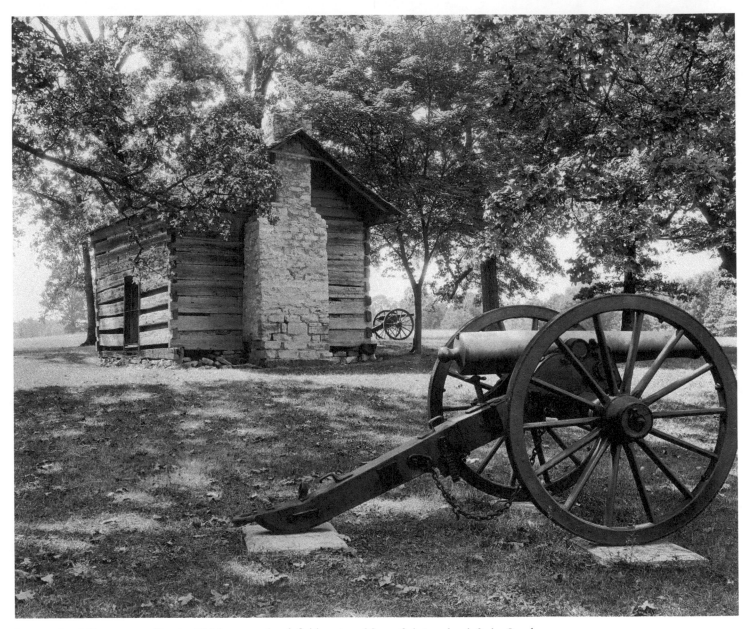

Just south of Chattanooga lies the Chickamauga battlefield, a site of fierce fighting that left the South with a stunning victory. The Brotherton house was the site of a relentless charge by Confederate General Longstreet's troops that put the Union soldiers in rapid retreat in September 1863. (ca. 1940)

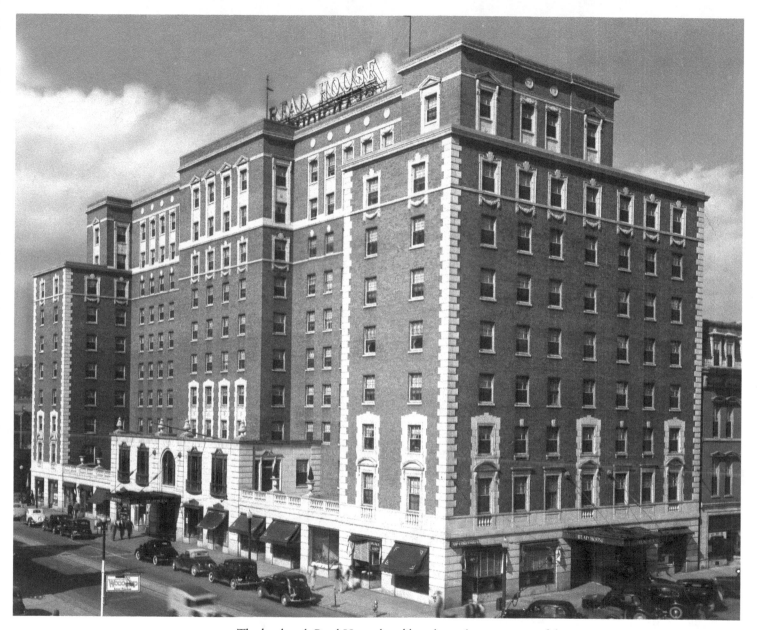

The landmark Read House hotel has always been a center of downtown activity. Located directly across from the Union depot, it has hosted a number of well-known personalities including Winston Churchill and Tallulah Bankhead. (ca. 1940)

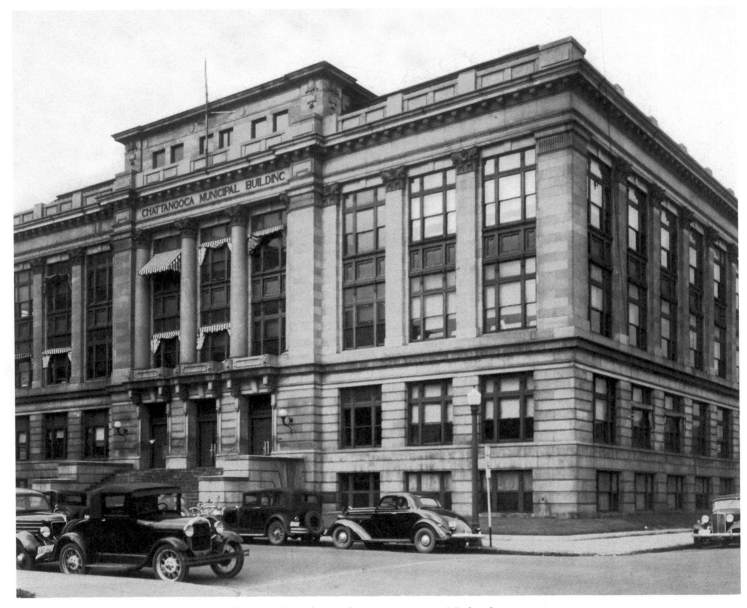

Chattanooga's Municipal Building was built in 1908, replacing the previous one at Market Square. Commonly referred to as City Hall, it still houses the mayoral and administrative offices. Photograph by Matt L. Brown & Co. (ca. 1940)

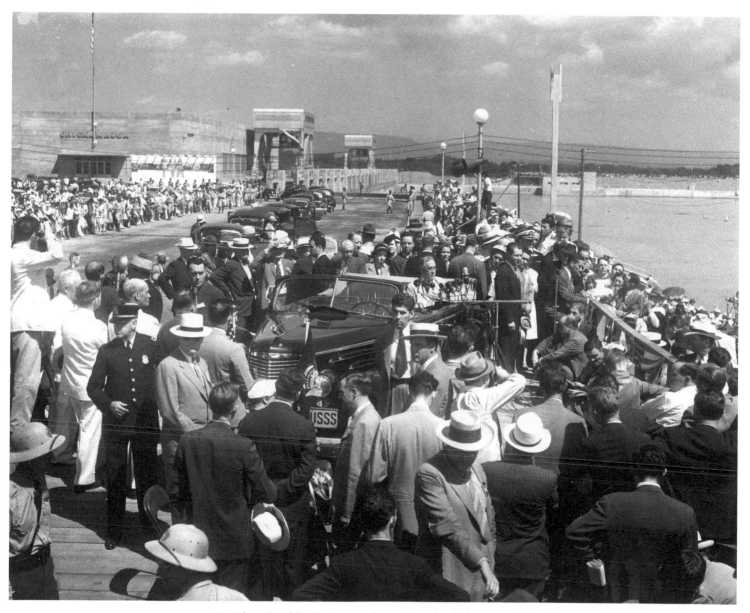

President Franklin D. Roosevelt speaks at the dedication of the Chickamauga Dam on September 2, 1940. The dam project, funded through tax dollars, brought badly needed jobs to the valley during the hard times of the Great Depression and made the Tennessee Valley Authority a permanent part of life in Chattanooga.

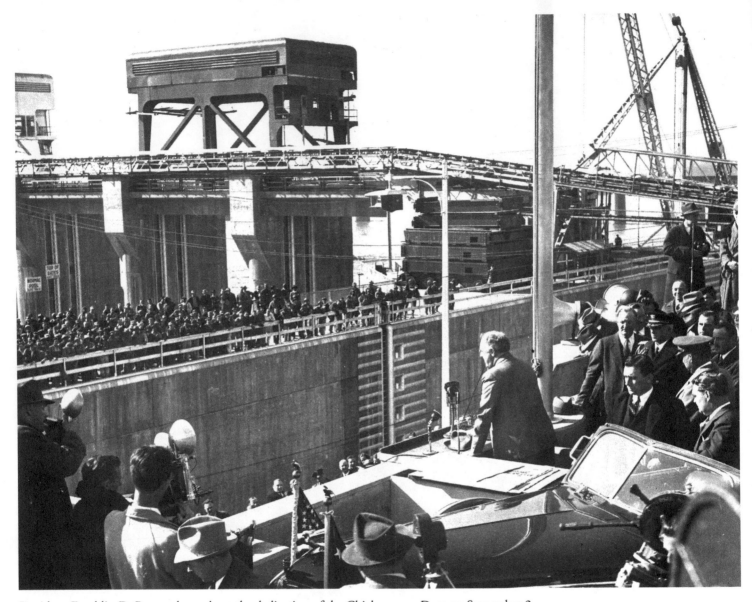

President Franklin D. Roosevelt speaks at the dedication of the Chickamauga Dam on September 2, 1940. Having succumbed to polio earlier in life, he was unable to walk. The view from behind his automobile reveals how he supported himself on the side of the vehicle's doors. He would be elected to an unprecedented fourth term in office two short months later.

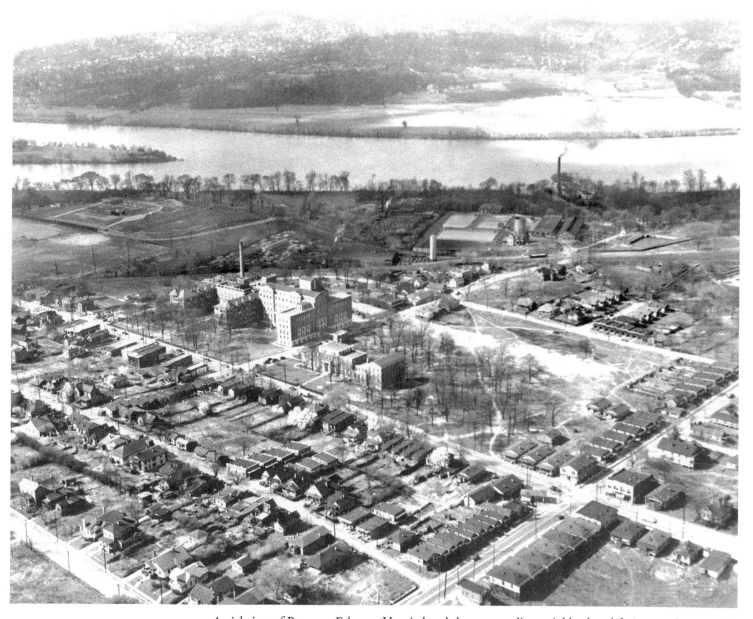

Aerial view of Baroness Erlanger Hospital and the surrounding neighborhood facing north across the Tennessee River. (1941)

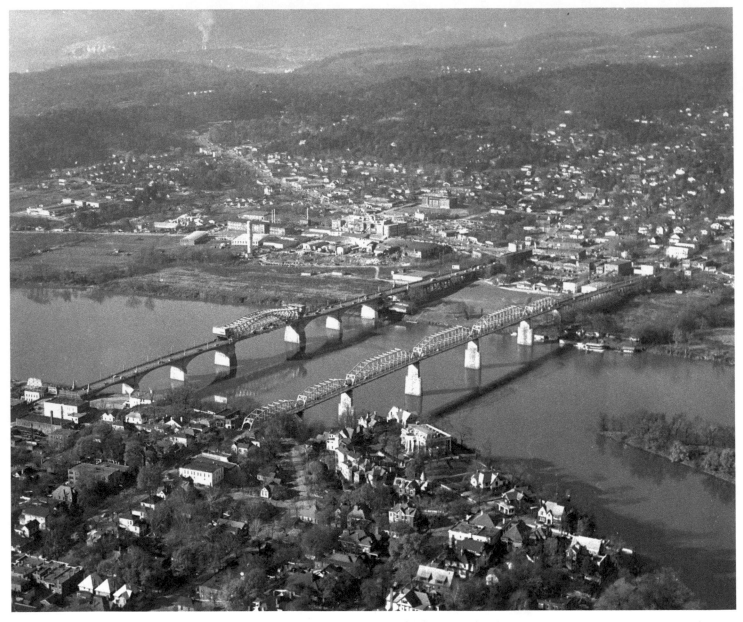

This aerial view of Chattanooga shows the Market Street and Walnut Street bridges over the Tennessee River. Completed in 1917, the Market Street Bridge (at left) is a concrete drawbridge that would undergo a complete renovation in 2005. (ca. 1940)

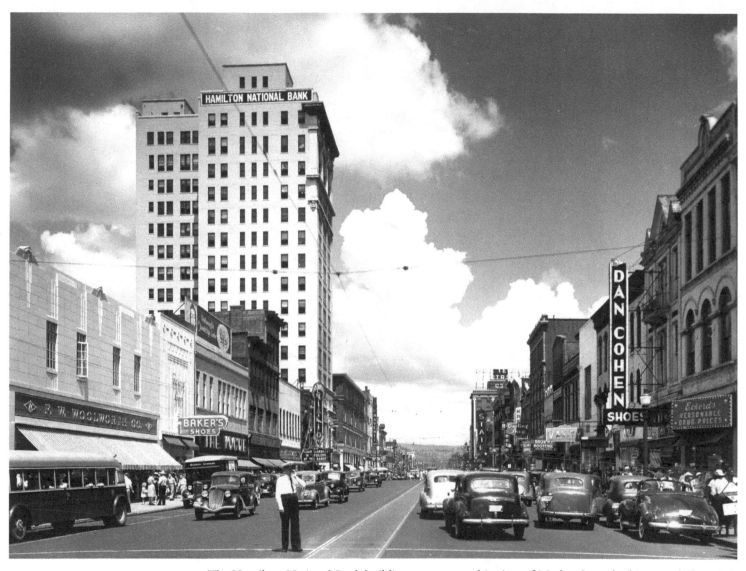

The Hamilton National Bank building towers over this view of Market Street looking north from 8th Street. Photograph by Matt L. Brown & Co. (1942)

Assembly-line work was one kind of job available to women. Three women workers at Brock Candy Company make sure these delicacies are ready for packing. (ca. 1945)

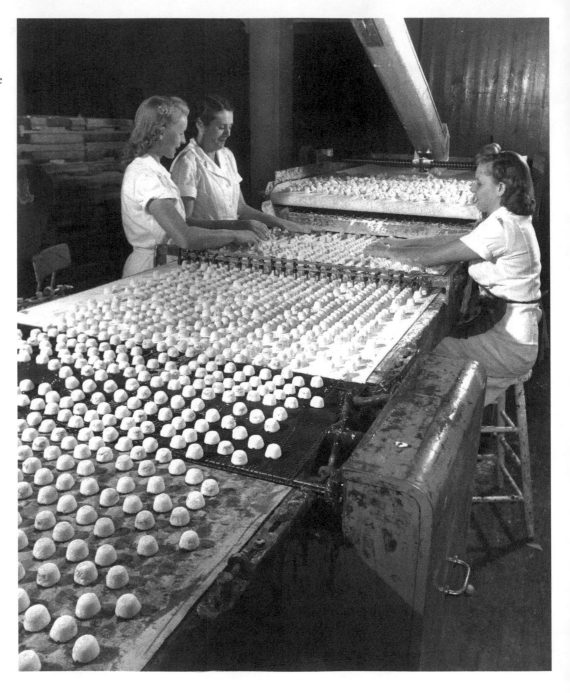

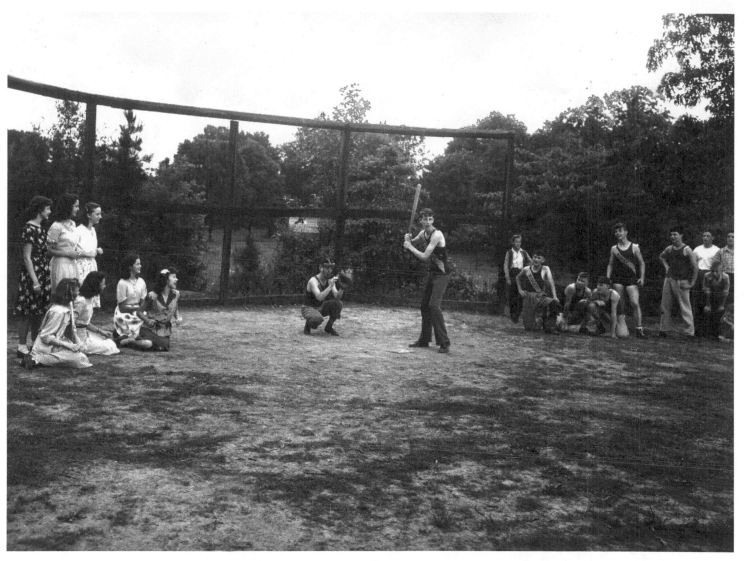

Student at Brainerd Junior High School takes his turn in the batter's box while fellow students cheer him on from the sidelines. (1945)

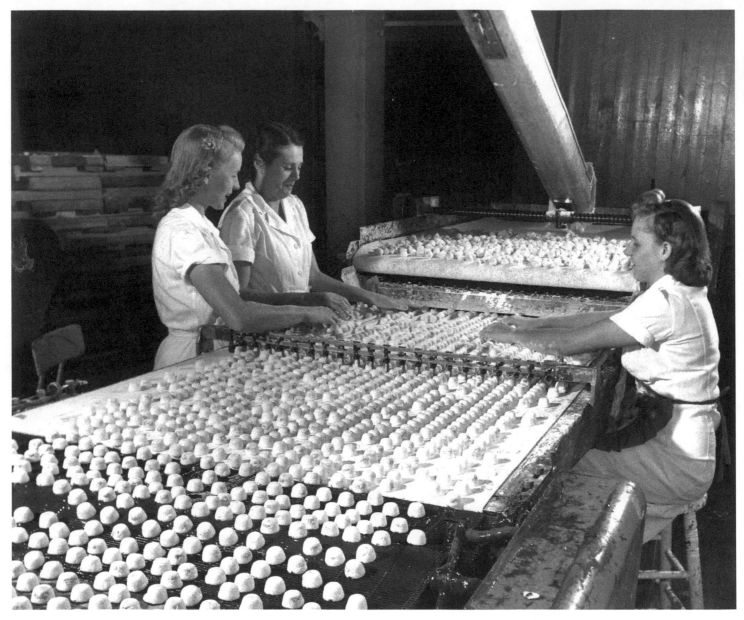

These men are studying engine dynamics at Porter's Flight School. The school, which Harry Porter ran for more than 30 years, qualified as a certified U.S. Army pilot training site during the Second World War. (ca. 1945)

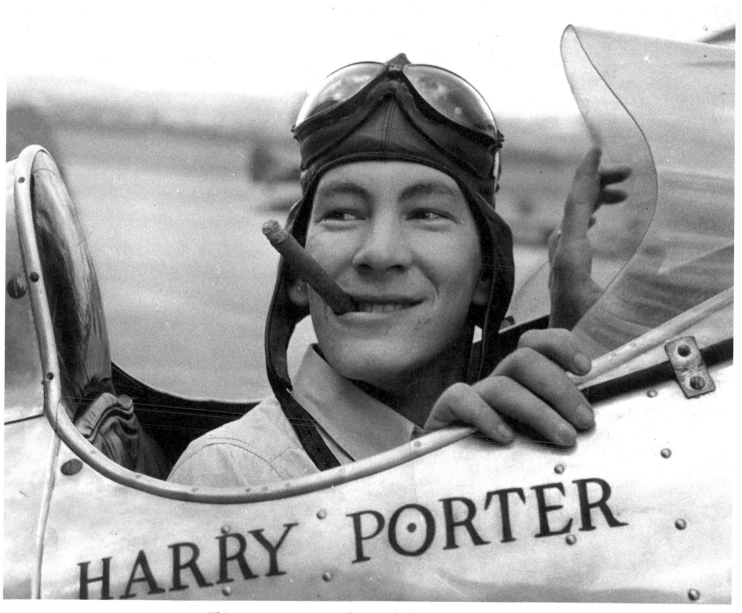

This young man was one of many who learned to fly at Porter's Flight School at Lovell Field. Owner Harry Porter, who first flew in 1923, had an active sixty-four-year career in aviation. At the age of ninety, he was recognized as the oldest active pilot in the United States.

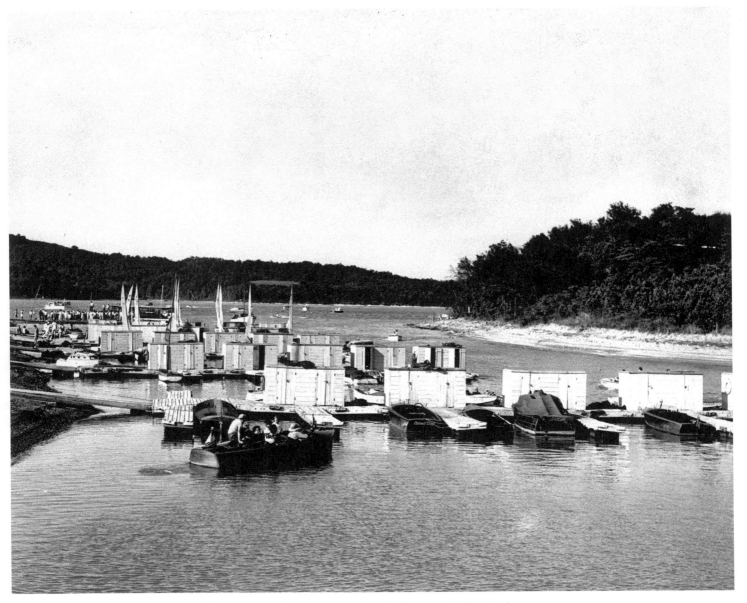

The Chickamauga Dam brought flood control and cheap electricity to the Tennessee Valley. It also created Chickamauga Lake, which has been a source of fun and recreation for more than 60 years. (September 1945)

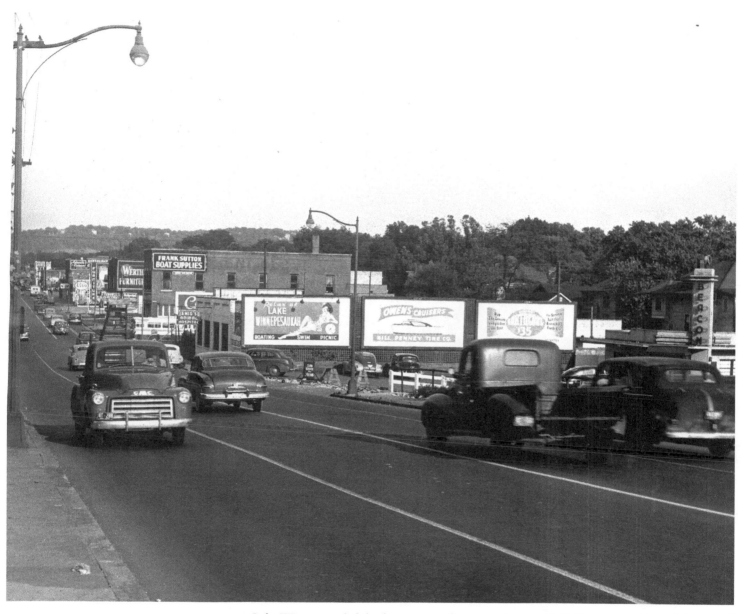

Lake Winnepesaukah beckons to speeding motorists on McCallie Avenue. Named for one of Chattanooga's oldest families, McCallie Avenue runs east from Georgia Avenue in downtown Chattanooga to Missionary Ridge, which is visible in the distance. (ca. 1949)

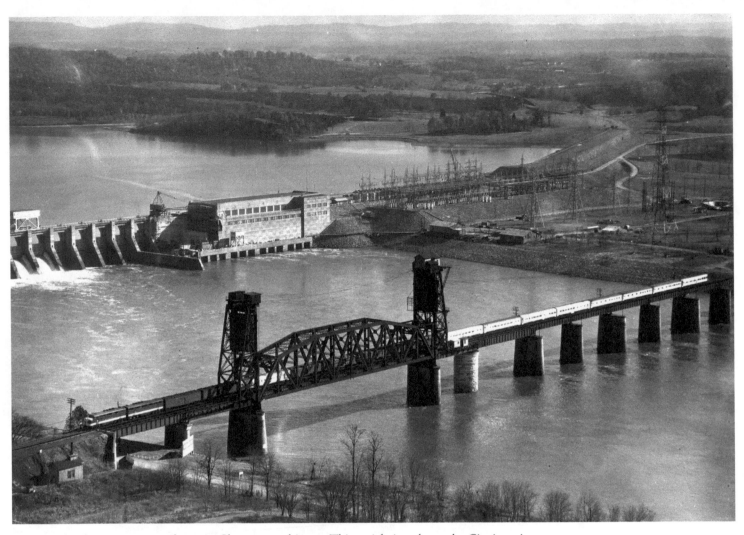

Rivers and rails are a constant theme in Chattanooga history. This aerial view shows the Cincinnati Southern Railway bridge across the Tennessee River with the Chickamauga Dam in the background. (ca. 1945)

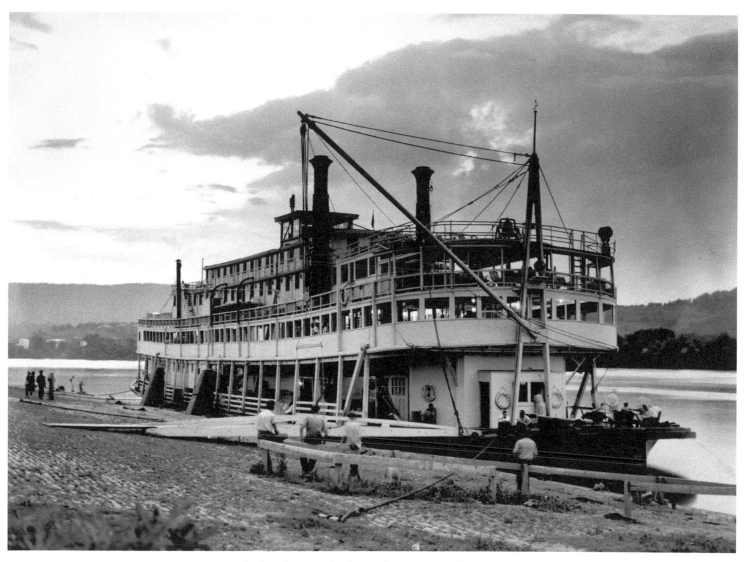

Docked at the city wharf on a day in June is the steamboat *Gordon Greene*. Built in 1923, it was in service until it was retired in 1952. The boat then became a floating hotel before sinking in 1964 at St. Louis. (1946)

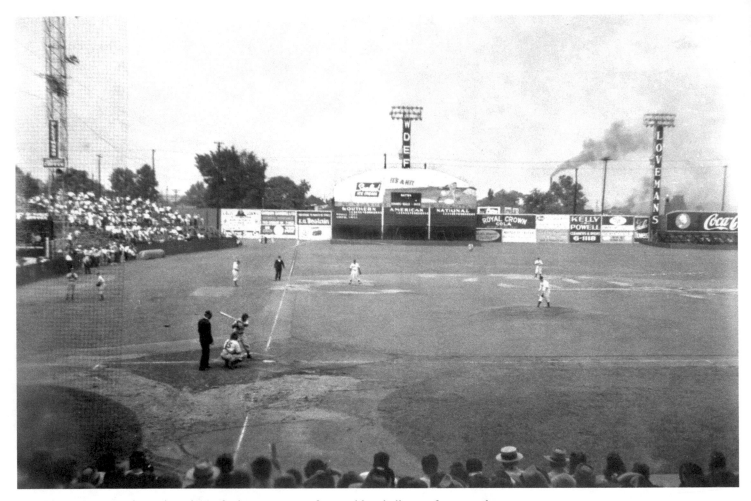

The Chattanooga Lookouts have been the hometown professional baseball team for more than a century. Here they are shown playing at Engel Stadium, their field of dreams where they featured such greats as Harmon Killebrew and Ferguson Jenkins. In 2000, they moved to their new facility, BellSouth Park, downtown overlooking the Tennessee River. (1947)

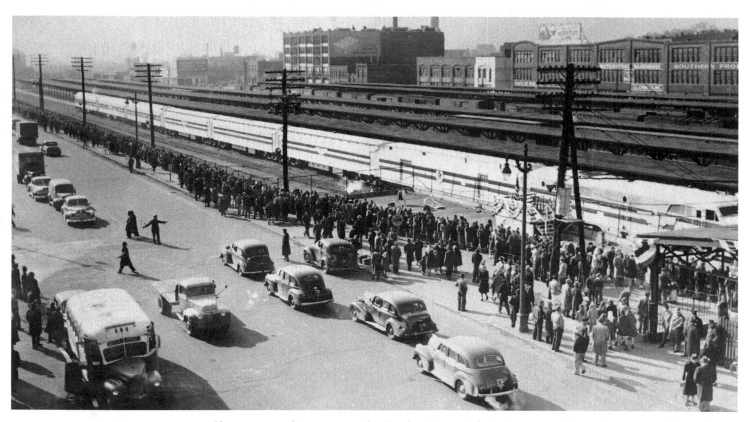

Chattanoogans line up to see the Freedom Train with its important historic documents. Some 12,000 Chattanoogans came to see the treasures, many of whom waited as long as three hours. Among the artifacts were Thomas Jefferson's draft of the Declaration of Independence and George Washington's copy of the Constitution. (January 2, 1948)

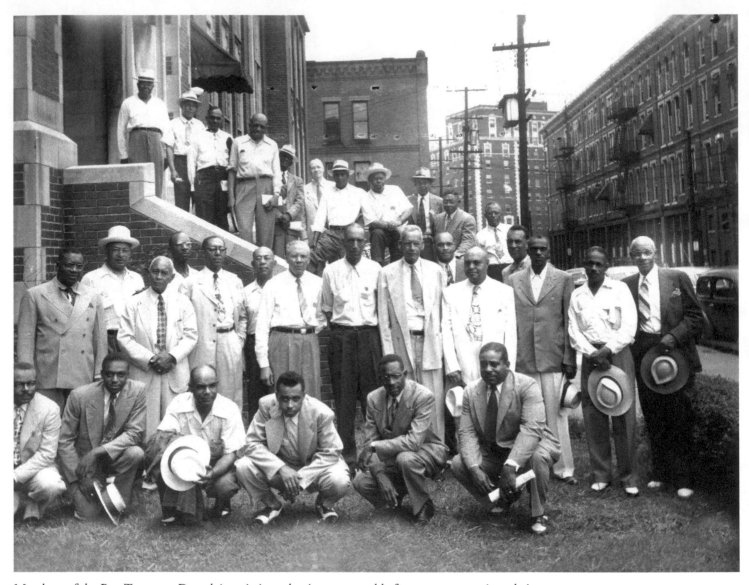

Members of the Pan-Tennessee Dental Association take time to assemble for a group portrait at their 15th annual convention. A growing class of medical professionals was vital to the African-American community in the segregated South. (1948)

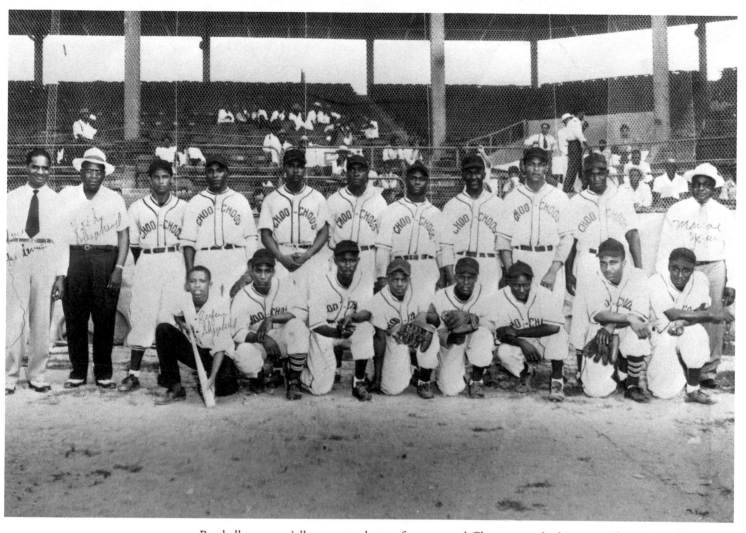

Baseball was a racially segregated sport for years and Chattanooga had its own African-American team, the Chattanooga Choo-Choos. In the center of the front row of this photograph kneels a young player named Willie Mays, who would someday join the Baseball Hall of Fame as one of the great center fielders. (1947)

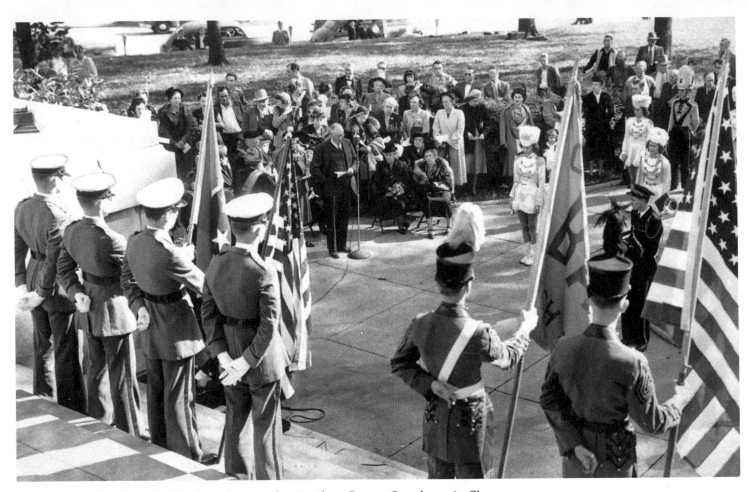

Dedication of the Alexander Hamilton plaque at the Hamilton County Courthouse in Chattanooga. Present are members of the Central High School color guard. Judge Wilkes T. Thrasher accepts the marker on this occasion. (November 2, 1949)

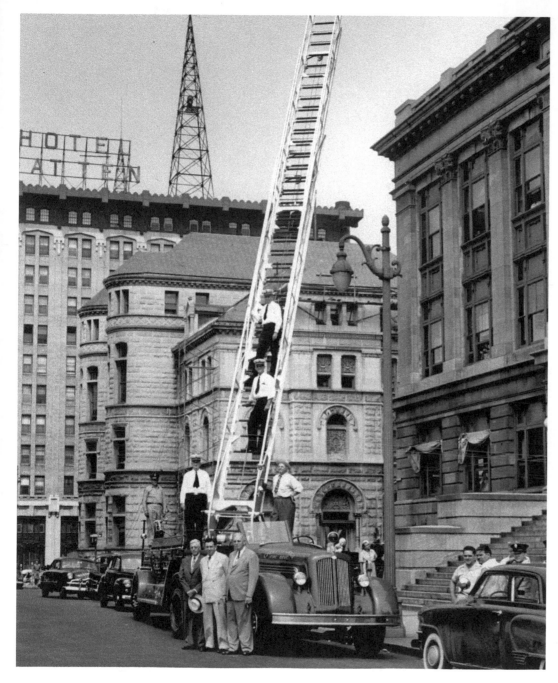

Members of the Chattanooga Fire Department and several dignitaries display the new Hugh P. Wasson aerial ladder and fire truck in front of City Hall. (August 25, 1949)

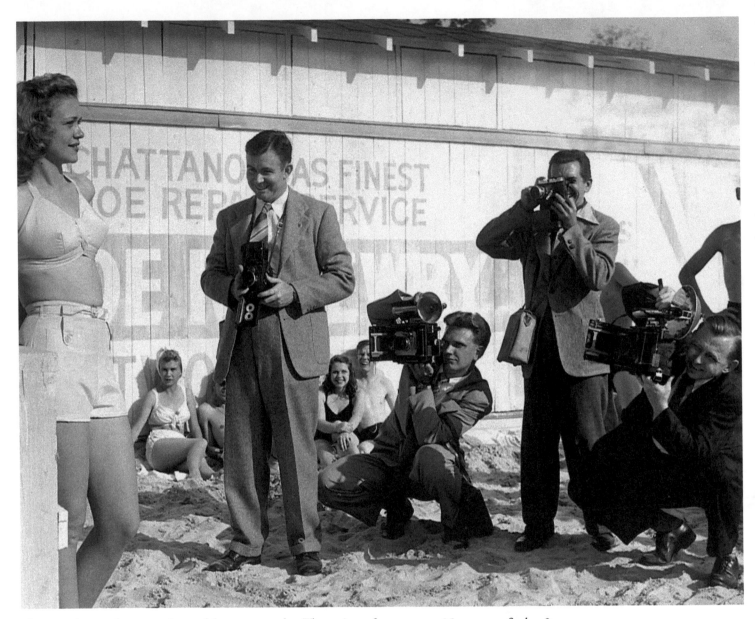

Photographers gather around a model on a sunny day. The variety of cameras—a 35mm rangefinder, 2 ¼, and 4 x 5 Speed Graphic—suggests that this is a camera club outing. (ca. 1948)

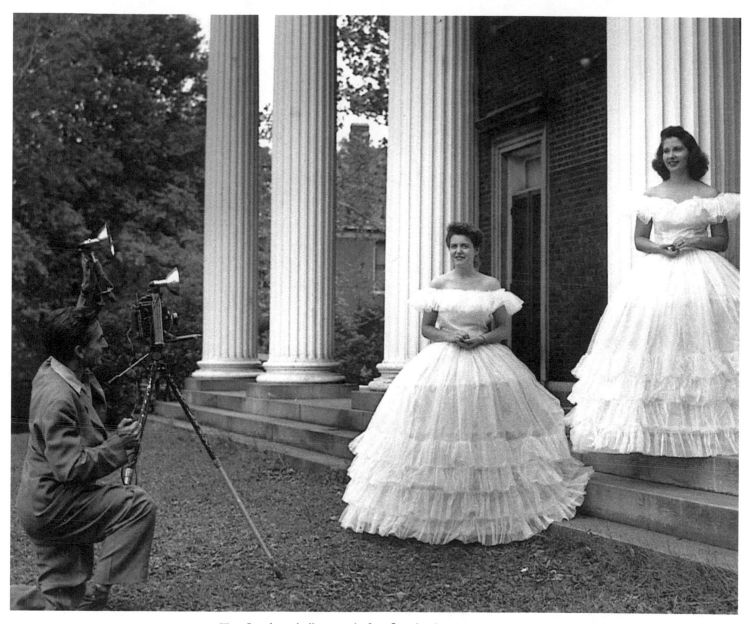

Two Southern belles pose before fluted columns patiently waiting for the photographer to make the perfect exposure. Photograph attributed to Bob Sherill (ca. 1948)

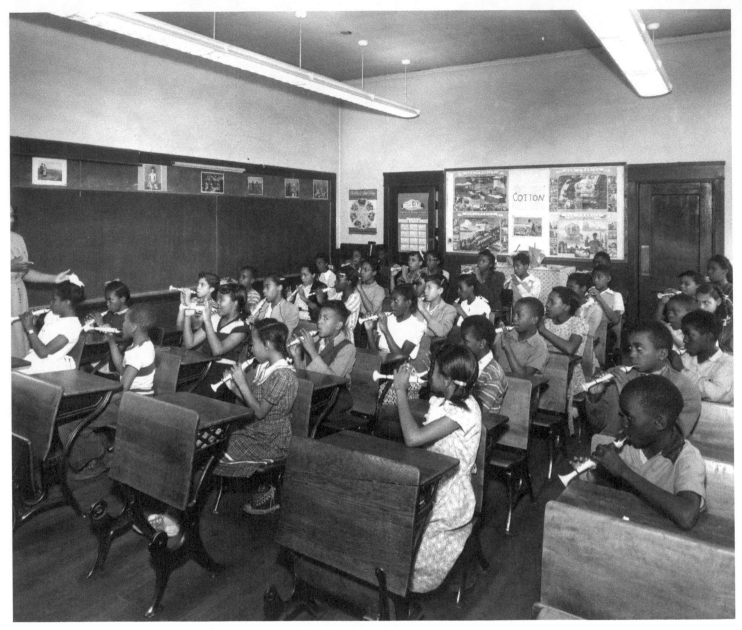

Sixth-grade students at Calvin Donaldson Elementary School practice their scales using flutophones. (1950)

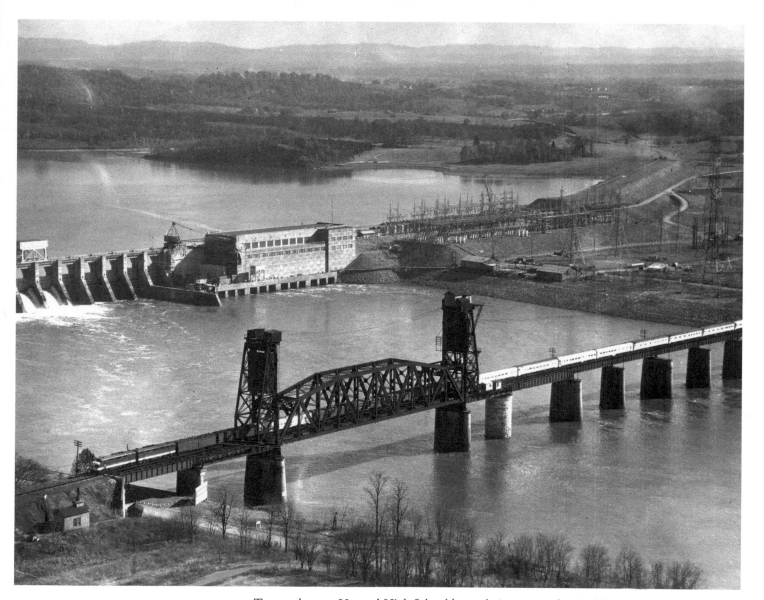

Two students at Howard High School hone their auto mechanic skills in vocational class. The school has its origins in the Howard Free School, which was begun in 1865 after the Civil War. Still in operation today, the school was named for General Oliver O. Howard, commissioner of the Freedman's Bureau. (1950)

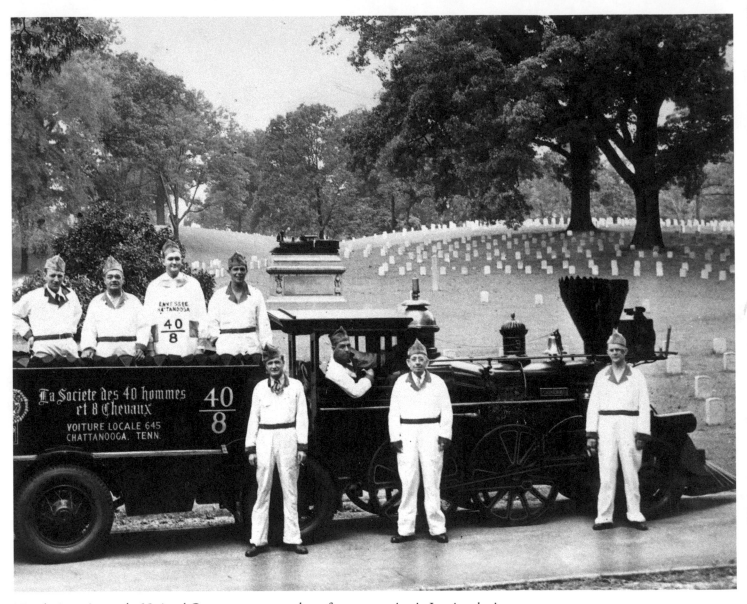

Nine legionnaires at the National Cemetery prepare to leave for a convention in Los Angeles in a replica of the Civil War steam engine the *General*. The model was built by Fassnacht and Sons in 1938. A smaller version of the engine rests on the Andrews' Raiders monument in the background.
Photograph by John Goforth (September 29, 1950)

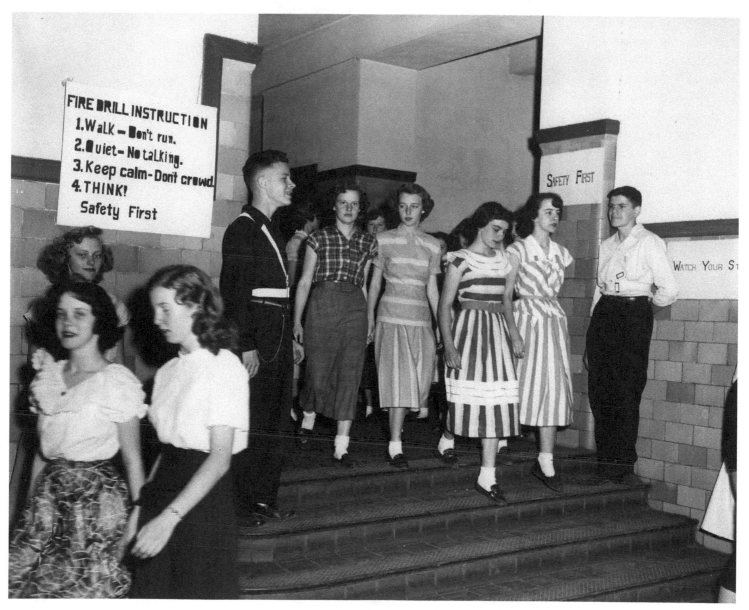

A sign on the wall at Brainerd High School reminds students to "walk – don't run" as a fire drill is carried out in orderly fashion. (1951)

A line forms in front of the Rogers Theater for the opening-day showing of *Three Guys Named Mike* with Van Johnson and Jane Wyman. Downtown movie theaters were thriving in the 1950s as this crowd demonstrates. Opened in 1951 with seating for 1,257 patrons, the motion picture house on Market Street closed its doors in 1976 as shopping mall movie screens became the choice of the viewing public. (1951)

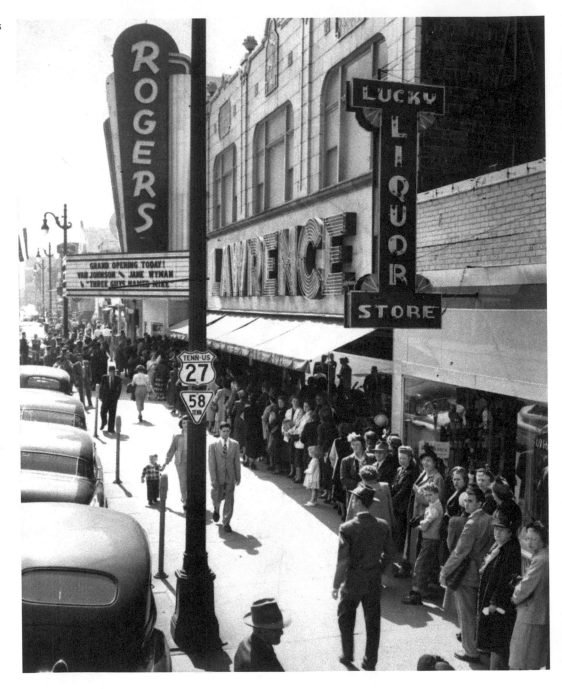

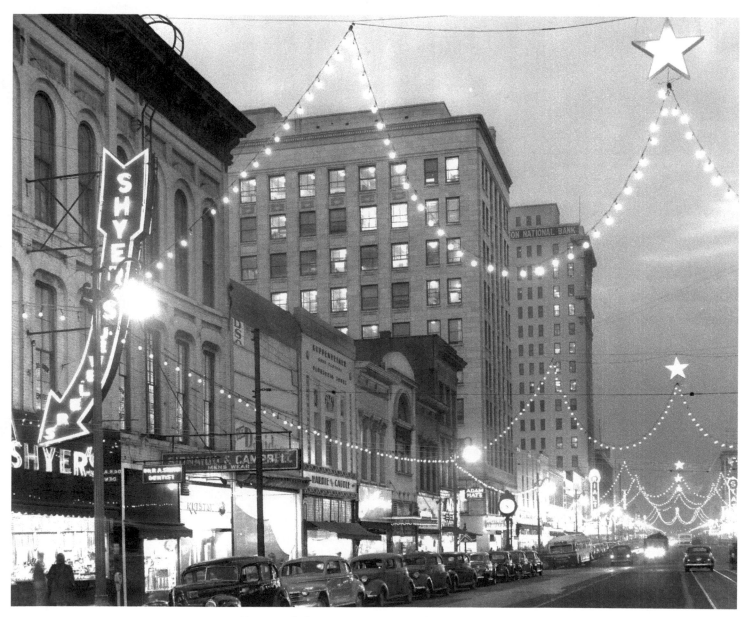

Christmas lights set Market Street aglow on a winter night. Before the advent of shopping malls, downtown stores were the place to do holiday shopping. Photograph by Roy Tuley (ca. 1950)

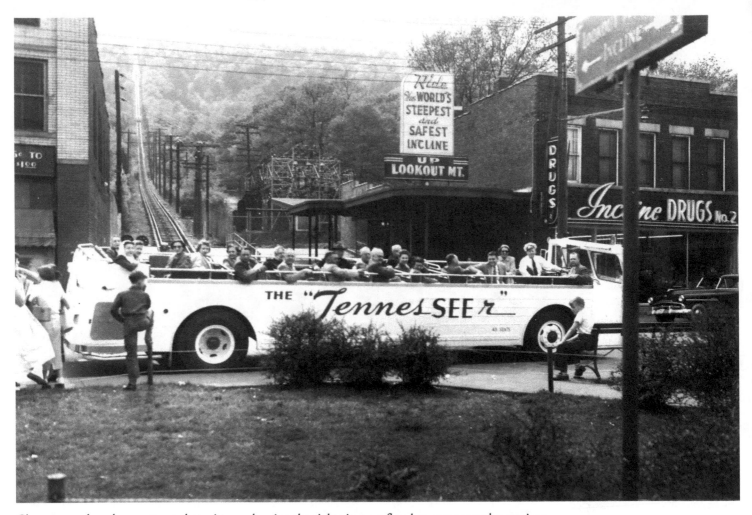

Chattanooga has always attracted tourists, and seeing the sights in a roofless bus was a popular pastime in the 1950s. The vehicle "the TennesSEEr" sits in front of the perpetually popular Lookout Mountain Incline, built in 1895 and billed as "America's Most Amazing Mile," because of its steep grade. (April 18, 1952)

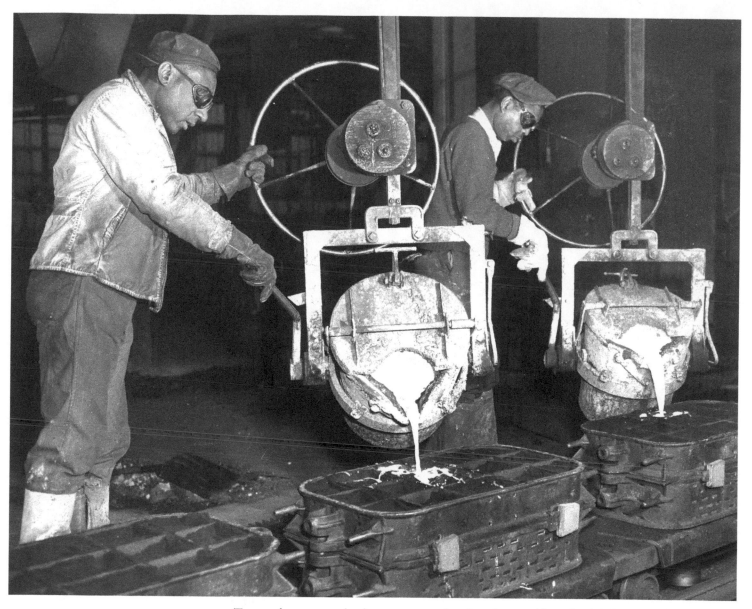

Two workers operate buckets to pour molten iron into molds at the Wheland Foundry. In an era when the South was segregated and many jobs were closed to blacks, factory work provided African-Americans with a steady income.
(ca. 1952)

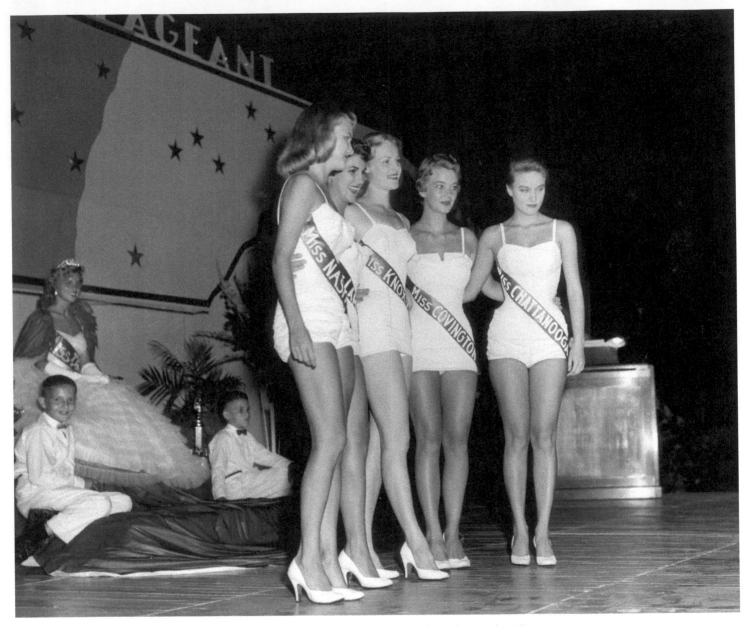

Chattanooga beauty Marilyn Harris (far right) and four other contestants pose for judges at the Miss Tennessee Pageant in Madison County. (July 1955)

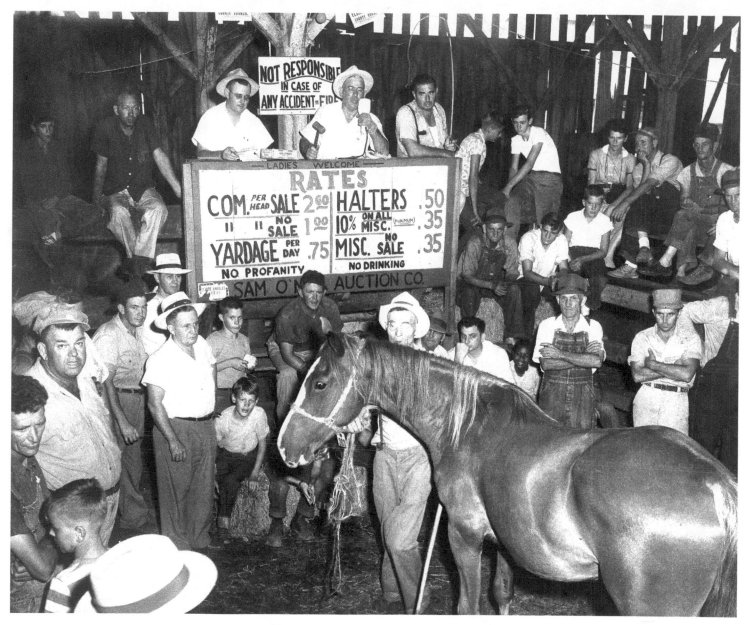

Bidders at Sam O'Neil Horse and Mule Barn in St. Elmo eye the horseflesh on display as the auctioneer entices buyers to bid. A sign below the podium reads "No profanity / No drinking." (ca. 1955)

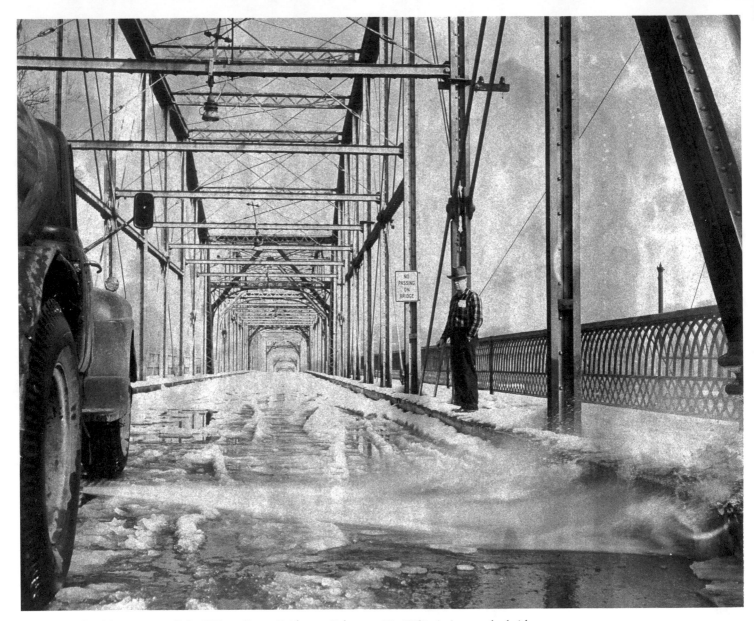

A street washer blows snow off the Walnut Street Bridge on February 17, 1960. A sign on the bridge prohibits vehicles from passing each other, because of the narrow width of the roadbed. James Templeton of the Public Works Department stands to the right. Photograph by J. B. Collins

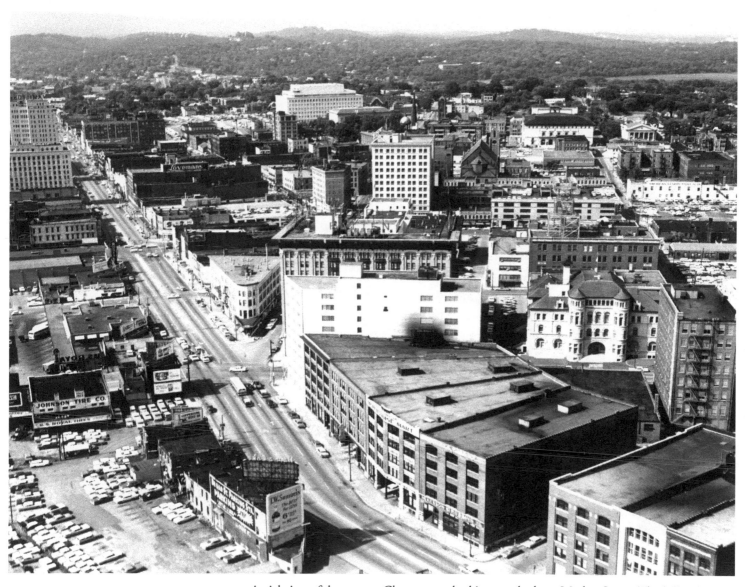

Aerial view of downtown Chattanooga looking north along Market Street. The hills of North Chattanooga are visible in the background.

(ca. 1960)

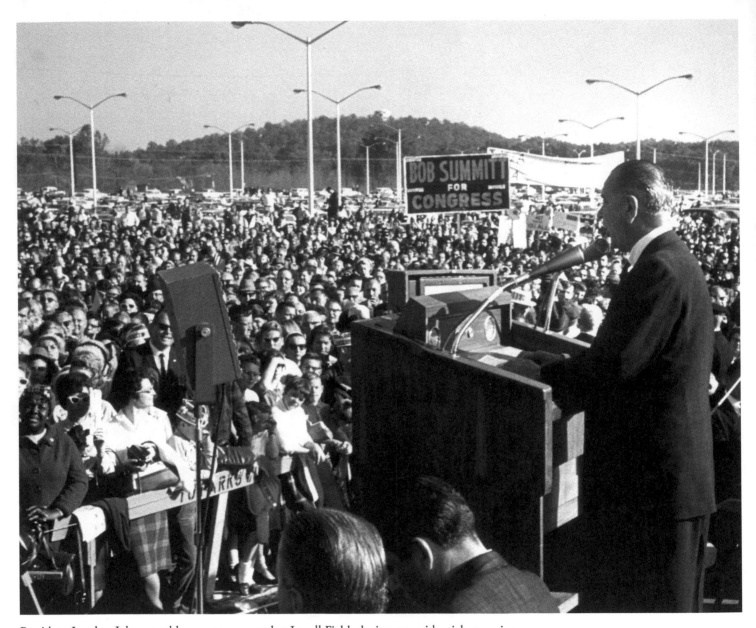

President Lyndon Johnson addresses a rapt crowd at Lovell Field, during a presidential campaign visit in October 1964. Johnson was elected in a landslide victory over Republican Barry Goldwater, carrying the state of Tennessee comfortably. Photograph by W. C. King (1964)

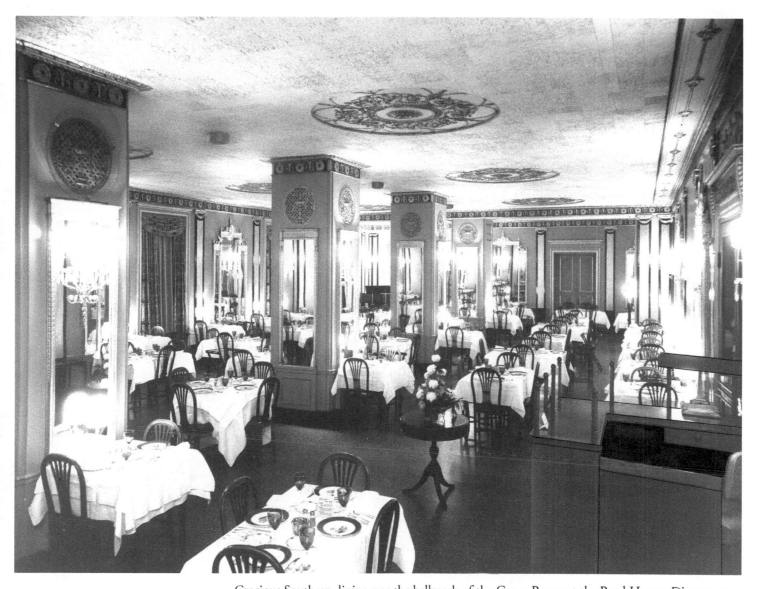

Gracious Southern dining was the hallmark of the Green Room at the Read House. Dinners were often accompanied by live music. Unfortunately, the Green Room was closed in 2004 when the hotel was renovated. (ca. 1968)

The Volunteer State Life Insurance Building was constructed in 1917. Also referred to as the Volunteer Building, this Neoclassical edifice on Georgia Avenue publicized its name by placing the sign on top of the roof in 1964. (ca. 1966)

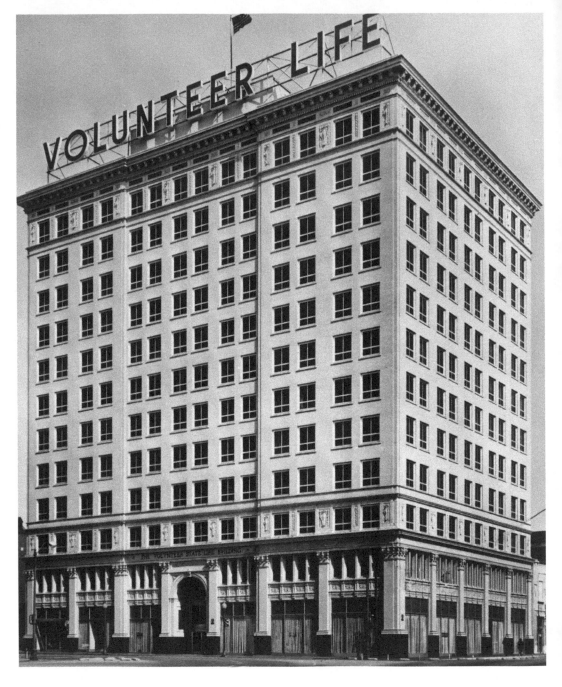

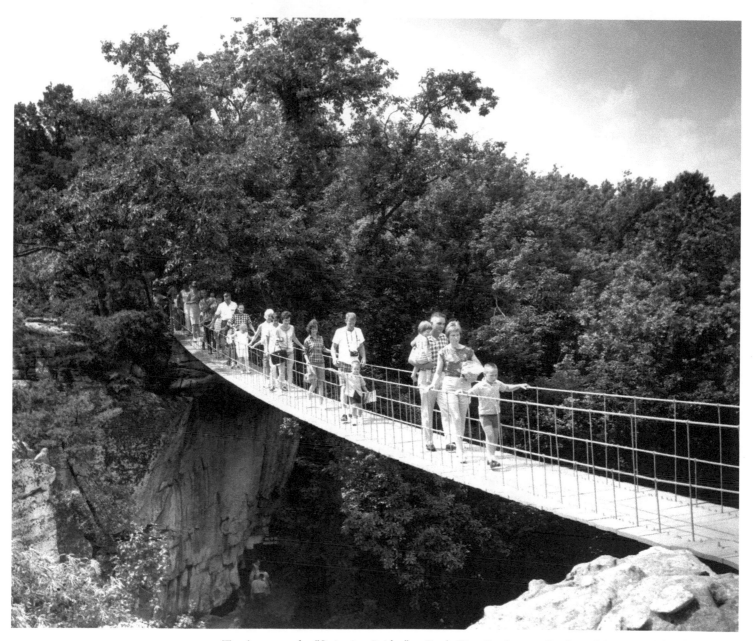

Tourists cross the "Swinging Bridge" at Rock City Gardens on Lookout Mountain. This fascinating group of natural rock formations was turned into a famous attraction in 1932 by Garnet and Frieda Carter. (1967)

Notes on the Photographs

These notes, listed by page number, attempt to include all aspects known of the photographs. Each of the photographs is identified by the page number, a title or description, photographer and collection, archive, and call or box number when applicable. Although every attempt was made to collect all data, in some cases complete data may have been unavailable due to the age and condition of some of the photographs and records.